IMAGES
of America

COLOMA

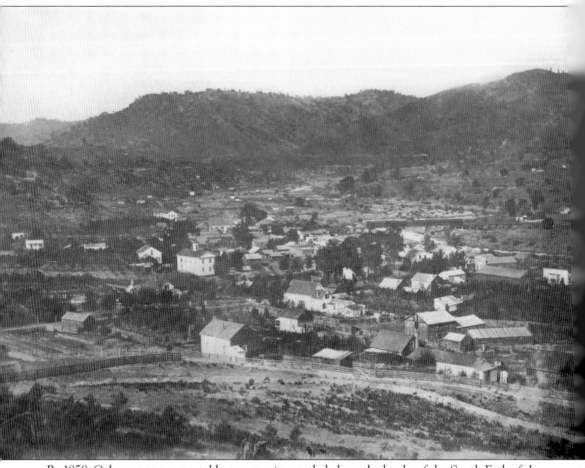

By 1858, Coloma was a respectable community nestled along the banks of the South Fork of the American River. Fine homes ringed a bustling Main Street, crowded with hotels and stores of all kinds. The El Dorado and Coloma Breweries served the populace, and winemaking was in its nascence. A covered bridge linked the two sides of town. (Courtesy of Marshall Gold Discovery State Historic Park.)

ON THE COVER: In 1883, four local men demonstrate mining techniques near the gold discovery site. Shown from left to right are fruit grower Charles Johnson, miner Phil Teuscher, blacksmith Rufus Burgess, and miner Commodore P. Young. Just visible in the background is a footbridge that was replaced by a more permanent structure in 1917. (Courtesy of Marshall Gold Discovery State Historic Park.)

IMAGES
of America

COLOMA

Betty Sederquist

ARCADIA
PUBLISHING

Copyright © 2012 by Betty Sederquist
ISBN 978-0-7385-9549-8

Published by Arcadia Publishing
Charleston, South Carolina

Printed in the United States of America

Library of Congress Control Number: 2011945617

For all general information, please contact Arcadia Publishing:
Telephone 843-853-2070
Fax 843-853-0044
E-mail sales@arcadiapublishing.com
For customer service and orders:
Toll-Free 1-888-313-2665

Visit us on the Internet at www.arcadiapublishing.com

This book is dedicated to my late father and proud Coloma state park ranger, Harold Sederquist. He also loved and researched Coloma history.

CONTENTS

ACKNOWLEDGMENTS

Many people made this book possible, from the amazing researchers and historians who worked their magic in earlier years to contemporary helpers. Marilyn Parker gave many days of her time, commuting from Pollock Pines to be of assistance. Ranger Mark Michalski helped reveal the amazing trove of photographs in the Marshall Gold Discovery State Historic Park research library. Park superintendent Jeremy McReynolds also helped expedite access to the state park collections. Michael Okey assisted with research and helped organize the state park photograph collection for scanning, donating many days of his time in the process. The knowledgeable librarians of the California Room in the California State Library heroically tracked down and obtained permission to reproduce images captured from the library's extensive collection. The Gold Discovery Park Association also deserves special thanks for keeping Gold Rush history alive and for providing many resources. Thanks also to the American River Conservancy for sharing their material on the Wakamatsu Colony.

Thanks go out to all of the local families who generously shared photographs from their personal collection, including Bill Bacchi, Kurt de Haas, Pearl de Haas, Merv de Haas, Papini descendants Vickie Fancher Longo and her siblings Rita Archie and Philip Fancher, Dan Mainwaring, Clarence and Betty Nichols, Wayne Ragan and family, John Tillman, Allan Veerkamp, and Barbara Wagner Veerkamp. Bill and Robin Center of Camp Lotus provided slides and information about the early days of whitewater rafting and kayaking. Doug Noble shared his knowledge of El Dorado County. Mike Lynch provided information about California state parks. Ed Allen, Rodi Lee, Michael Okey, Sara Schwartz Kendall, Dave Sederquist, and Randy Sederquist spent many hours reviewing the manuscript. Finally, a special thanks to my husband, Steven de Haas, for his patience (and proofreading) during this long process.

Unless otherwise noted, most of the images in this book are from the California State Library (Courtesy of the California History Room, California State Library, Sacramento, California) and Marshall Gold Discovery State Historic Park (MGDSHP).

INTRODUCTION

On a January morning in 1848, James Wilson Marshall was inspecting the tailrace of a sawmill he was building along the South Fork of the American River for Capt. John (Johann) Sutter. He glanced down and saw something shiny. The gold nugget he found changed the future of not only the little valley where the sawmill was located but also California and points beyond. Although California gold had been previously found in 1838 near Los Angeles, this new discovery reshaped the destiny of the American West.

Sutter, originally from Switzerland, had established a fort in 1839 on his Mexican land grant near the junction of the Sacramento and American Rivers. He needed lumber for his 48,827-acre empire and dispatched Marshall, a carpenter from New Jersey by way of Indiana, Kansas, Oregon, and the Bear Flag Revolt, to find a suitable sawmill site. He needed running water to power the mill, plenty of trees to cut into lumber, and relatively easy access to Sutter's Fort. In May 1847, Marshall found the Cullumah Valley. The name derives from the Nisenan word for "beautiful valley." Until the discovery, the Sierra Nevada foothills were inhabited by the Nisenan native peoples. On August 27, 1847, Sutter signed a contract with Marshall in which Marshall would erect and operate the mill and Sutter would supply labor, equipment, and supplies. The next day, Marshall and John Wimmer (Weimer) headed for the Cullumah Valley so they could begin staking out the foundations of the mill. Wimmer's large family soon followed, along with two wagons of provisions and tools. Added to the group were at least five Mormons who had mustered out of the Mormon Battalion. Some of Sutter's native workers also came, herding sheep.

The group built a log cabin with a common roof to house the Wimmers and the Mormon workers. A sheet separated the two groups. It was located on the south side of the river, close to the mill site. Marshall built his own cabin close by. By December, construction began in earnest. In early January 1848, the crew completed a brush dam, weighted down by stones and timber. Marshall, after working on patterns for mill irons at Sutter's Fort, returned to Coloma on January 14. The tailrace was too shallow, so the saw could not be powered because of water backup in the tailrace. So workers deepened the tailrace, digging during the day. At night, they opened the gates of the forebay to allow the water to run through the tailrace, purging it of excavated waste.

On the morning of January 24 (although Marshall contended to his dying day that it was January 19), Marshall picked up the now-famous shiny metal from the gravel of the tailrace. Uncertain that the metal was gold, he gave the nugget to Martin, Wimmer's son, who took it to his mother, camp cook Jenny Wimmer. She had been part of a small gold rush in Georgia and knew how to test the metal. She put the nugget in a kettle of soft lye soap she was preparing, cooling it until the next morning. At the bottom of the kettle sat the gold, shining brightly, unaffected by the lye. Years later, she claimed in a sworn deposition that her husband Peter had discovered the gold, not Marshall. A laborer, Charles Bennett, claimed he found gold first. His tombstone in Oregon proclaims him the discoverer.

Marshall immediately made a deal with the workers, establishing some land boundaries. Also, he would take 25 percent of whatever gold they found in exchange for food, clothing, and farm implements. He then agreed with the Nisenan leaders to lease land around the sawmill.

On January 28, Marshall slogged through rain and mud to Sutter's Fort and met privately with Sutter. In vain, Marshall and Sutter tried to keep the discovery secret. The next day Sutter rushed to Coloma, finding enough gold to make a 1.5-ounce ring. He also talked to the Nisenan leaders and from them obtained a three-year lease on a tract about 10 by 12 miles in size in return for trinkets. He promised them that they could live in their homes undisturbed—a promise soon broken, but not by Sutter.

Returning to the fort, Sutter needed to clarify land rights. California was in limbo at the time because of the influx of Americans and the Bear Flag Revolt. He dispatched fort worker Isaac Humphreys to Monterey, then the capital of California, to meet with Col. Richard B. Mason, military governor of California. Humphreys, who had dug gold in Georgia, took a bag containing about six ounces of gold dust from the sawmill site as proof of the discovery. Along the way, he stopped at Pfister's store in Benicia. The gang there was excited about a recent coal discovery near Mount Diablo. "Coal!" exclaimed Humphreys. "Hell! I have something here which will beat coal and make this the greatest country in the world! Gold!" He then showed the gold to his astonished listeners.

Another leak came from a loose-lipped teamster who had gone to the sawmill, then returned to Sutter's Fort and paid for his drink with gold at Smith and Brannan's store. The store clerk told Sam Brannan, who immediately saw a golden opportunity; he bought up as many shovels, pans and other tools as he could and then walked the streets of San Francisco shouting, "Gold, gold from the American River!" Soon the shrewd merchant became California's first millionaire.

Within two months, the hills around Coloma, Auburn, and nearby Mormon Diggins, later called Mormon Island, were swarming with gold seekers. They upended the earth in the search for the precious metal. In just a few years, mine tailings and erosion choked the rivers, decimating salmon runs. The miners denuded the hills around Coloma searching for building materials and firewood. Between 1848 and 1967, California produced more than 106 million troy ounces of gold, about 35 percent of US production. Gold production peaked in 1853.

Word trickled to the east coast of the United States slowly because of the primitive transportation systems of the day. Mason, after an inspection of Coloma in July 1848, sent a report with Lt. Lucian Loeser about the California wealth to President Polk, along with 230 ounces of gold. The officer arrived in early December; the gleaming display electrified the good citizens of the eastern United States. Polk announced the gold discovery on December 5. The rush was on.

With the world economy in the doldrums, fortune hunters flocked to California from all over the world, although most of them came from the United States. The East Coast Argonauts, as they often called themselves, chose one of three routes. In the shorter sea route, they crowded onto ships that took them to a muddy and malaria-infested crossing over the Isthmus of Panama, and then boarded another ship north to California. Alternatively, they sailed the terrifying ship-swallowing seas of Cape Horn. Still others headed west by wagon train, a trip made dangerous by parched deserts, rugged mountains, and hostile indigenous peoples.

On they came, from Europe, China, Sonora, Chile, Australia, and beyond. Coloma, like other gold rush boomtowns, was a melting pot of all of these groups. Most were young men under age 30, although a few women—many of them prostitutes—joined the rush. One enterprising prostitute called "Texas Ellen" (Ellen Wilson) ran a thriving Coloma bordello. She named her establishment the Lone Star of Texas, and it was located by today's mill parking lot. The archetypal prostitute with a heart of gold, she cared for the ill, especially during the cholera epidemic of 1850.

Some miners took on new identities, and some abandoned families back home. One of the first Coloma store owners was Lansford Hastings, infamous for his dubious maps, one of which misled the Donner Party wagon train. The delay caused them to be tragically stranded in the snowy Sierras in the winter of 1846 and 1847. Another merchant, who briefly owned Sutter's Sawmill with John Winters, was lawyer Alden S. Bayley; he later built a grandiose hotel in nearby

Pilot Hill, vainly believing that the Transcontinental Railroad would be built close by. William Tecumseh Sherman, the noted Civil War general, also had a Coloma store.

In town, the tents, brush lean-tos, and crude log cabins of the first miners soon gave way to more permanent structures, although even some of these had dirt floors and canvas sides. Proprietors of saloons, gambling palaces, and brothels all parted the miners from their hard-earned gold dust.

The grand, wedge-shaped Wintermantel's Miner's Hotel was built at the corner of Bridge and Main Streets, where the Coloma Community Hall now stands. It was built by Louis Wintermantel, originally from Germany. An early-day newspaper advertisement included, in the list of hotel amenities, "A table always supplied with all the delicacies of the season; confectionery, cakes, and pies; bar in basement; also a fine billiard table; parties supplied at shortest notice." Another luxurious hotel was the two-story Sierra Nevada Hotel (also known as the Sierra Nevada House), situated just northwest of the site where today lie the remains of the Bell Store. Built in 1850 by Philip Schell and expanded by Robert Chalmers, the hotel was destroyed by fire in 1902. Other nearby hotels, including the Winters, American House, Orleans, Bakers, and Nichols, also offered fine accommodations.

Although most mining occurred here from 1848 until the mid-1850s, the quest for gold continued well into the 20th century. Miles of dredger tailings still furrow the edges of the river. In one ambitious 1850 scheme, miners tried to build a tunnel to divert water from the large river bend between Point Pleasant Beach and the present Highway 49 Bridge. Their goal was to mine the dry riverbed. However, the tunnel was not large enough, and water backed up and flooded parts of Coloma. The project was abandoned.

James Birch operated the first stage line from Coloma to Sacramento in 1849. The Adams Express Company and Wells Fargo & Company vied for express and banking customers until Adams Express went bankrupt during a financial panic in 1855. Wells Fargo maintained an office in Coloma until the 1870s.

Like many other Gold Rush communities, Coloma had a Chinatown, located about 300 yards north of the present museum. The closely huddled buildings burned in 1883. All that is left are two stone buildings, one of which has been restored as a Chinese store exhibit.

Slowly, Coloma gained respectability. Some men brought wives and families from their hometowns. By the late 1850s, the town boasted three churches, and merchants had built fine homes. Fire company members and other local social groups mingled at lavish dances, and Coloma folks looked for any excuse for a parade. About a mile upstream from Coloma, French Gardens, created by young bakery owner Alexandrine Gailleau, became a showplace of produce, fruit trees, and exotic flowers. Later, the Lamar family expanded the place. Known for their mulberry wine, the Lamars also created corsages for Coloma's women.

Within a few years of the discovery, surface gold in the Coloma Valley became harder to find. Miners, gamblers, and other hangers-on drifted to easier pickings. Although Coloma had been the county seat since 1850, with a courthouse, several lawyers, and a fine new stone jail, other communities—Georgetown, Diamond Springs, and Placerville—wanted the honor. In the first election to move the county seat, Coloma won the most votes, but Placerville folks shouted "skullduggery." According to one story, a resident of nearby Lotus possessed documents listing the crews and passengers of several vessels that were docked in San Francisco. The man voted in the name of every crewman and passenger. In a second election more than a year later, Placerville won on May 17, 1856, and the county seat moved there in 1857.

The move shaped the destiny of Coloma. It became a sleepy farming and ranching community. The 1860 US Census showed 884 people living in the town. The buildings constructed during the Gold Rush, many of them flimsy and crumbling, were dismantled to salvage and recycle their material or to retrieve any gold beneath them. The social activities of the tightly knit community, which included nearby Gold Hill and Lotus, centered around the IOOF Lodge (Independent Order of Odd Fellows), local churches, and the Sierra Nevada Hotel/Vineyard House. When the second Sierra Nevada Hotel burned in 1925, residents built the Coloma Community Hall, which still serves as a gathering place.

The famed discoverer of gold, James Marshall, struggled. First pushed aside by gold seekers disrespectful of his land rights and hounded by autograph seekers and others hoping his "luck" would rub off on them, he drifted from place to place before finally resettling in Coloma in 1857. There he grew wine grapes and supported himself doing odd jobs.

In 1872, the California State Legislature passed an "Act of Relief of James W. Marshall," under which he was paid from the state treasury the sum of $200 a month for two years. In 1874, they reduced the pension to $100 a month, which they paid until 1878. Marshall invested his pension in several mining properties, but his ventures failed. For seven years after his pension ended and until his death in 1885, Marshall lived in nearby Kelsey and supported himself mainly by blacksmithing and odd carpentry jobs.

The Gold Rush also adversely affected John Sutter. His inland empire crumbled as greedy miners squatted on his land, tearing down fences and destroying crops. Sutter died in relative obscurity. Most profoundly affected by the Gold Rush, however, were the peaceful Nisenan natives who had called the region home for thousands of years. The miners destroyed their way of life in the fertile Coloma Valley, brought disease, raided villages, and decimated native populations.

After the tumultuous years of the Gold Rush, the small town of Coloma slumbered for decades. The region's wineries, however, began to thrive. Martin Allhoff, from Germany, planted vineyards in the early 1850s on the hillsides south of Coloma. The skilled winemaker quickly found success; his Catawba grape cuttings that he had brought from Ohio produced one of the most popular Gold Country wines. After his 1867 death, his widow, Louisa, married a Scot, Robert Chalmers, owner of the lavish Sierra Nevada Hotel. Together they built the three-story Vineyard House—the largest building in Coloma—still standing over the valley. From the 1860s until the 1880s, El Dorado came close to matching the quantity and quality of wine made in Napa, Sonoma, and Santa Clara Counties. After Chalmer's death in 1881, winemaking declined due to the insect pest phylloxera and wine blight.

Coloma slowly rediscovered its Gold Rush identity as Californians began to realize the importance of the town in world history. Although Marshall died in relative obscurity and poverty, by 1890 his elaborate burial monument on a hill overlooking the discovery site gave him posthumous celebrity status. Thousands of people attended the monument's unveiling. Much later, George Johnson, Philip Bekeart, the Papini family, and Hero E. Rensch meticulously documented the town's history. In 1924, low river water revealed the foundation of Sutter's Mill, and workers hired by Bekeart quickly dug up the remains of the structure and built the large stone marker that remains today. In 1947, a scientific excavation established structural details and yielded hundreds of artifacts.

The centennial celebration of the discovery of gold in 1948 firmly secured Coloma's historical importance. An estimated 30,000 people crowded into the small town to see movie stars, politicians, and a grand parade.

Since then, Coloma has drawn millions of visitors eager to learn about the Gold Rush. Marshall Gold Discovery State Historic Park, established in the 1940s, has gradually expanded over the years and now features several museums and reconstructed historic buildings along with hiking trails and picnic areas. The World Gold Panning Championships took place here in 1998. Coloma also boasts a sister city, Clunes, site of Australia's first discovery of gold.

Relishing the valley's great beauty and swift-flowing river, rafters and kayakers discovered the recreational potential of the area by the 1960s, and by the mid-1970s, outfitters established several commercial rafting and kayaking companies. Today, there are dozens. Several beautiful campgrounds edge the river. Tourism is now the area's largest industry.

One

THE GREAT DISCOVERY

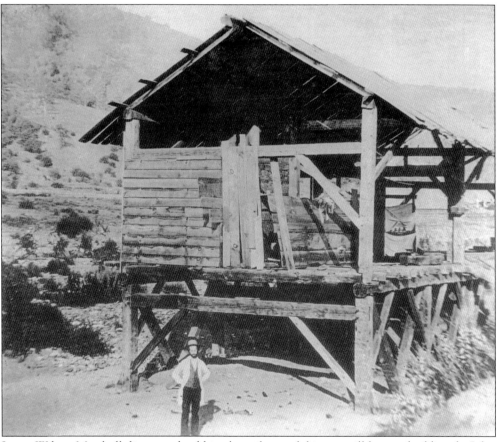

James Wilson Marshall discovered gold in the tailrace of this sawmill he was building for John Sutter in January 1848. This daguerreotype was probably made in the early 1850s, perhaps by Robert Vance. While many historians believe that the man in this image is James Marshall, other sources suggest that this was the daguerreotypist's assistant, posing to give scale to the structure. Others speculate it was Carlton Watkins, later a famed Yosemite photographer. (Courtesy of the California State Library, Sacramento, California.)

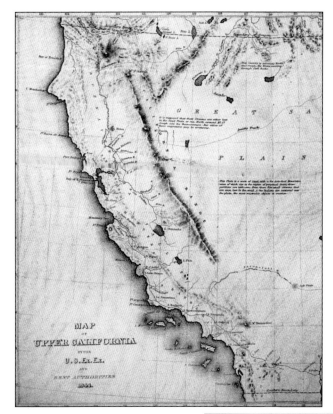

This map, made during the US Exploring Expedition, headed by US Navy lieutenant Charles Wilkes, shows that California was mostly wilderness in 1841, a few years prior to the Gold Rush. It shows San Francisco Bay as well as New Helvetia (Sutter's Fort) and the Sacramento and American Rivers. (Courtesy of the California State Library, Sacramento, California.)

The Coloma-Lotus Valley was home to a thriving Native American community before gold was discovered. The Nisenans were a branch of the Miwok tribe who lived easily off the land, hunting and foraging acorns, pine nuts, and other plants. James Marshall was on good terms with the native residents and hired them at the mill site. This etching shows a native woman pounding acorns into flour. Acorn grinding rocks still exist 200 yards north of the state park museum. (Courtesy of the California State Library, Sacramento, California.)

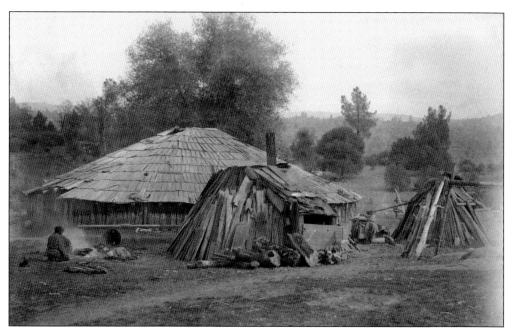

This magnificent roundhouse—used for ceremonial occasions—was located in El Dorado County. The Gold Rush proved tragic for California Native Americans. Land loss, disease, and rapacious attacks by gold hunters decimated their population. In 1848, an estimated 150,000 natives lived in California. Ten years later, that number had decreased to 20,000. (Courtesy of the California State Library, Sacramento, California.)

A NATIVE INDIAN CHIEF.

Before the Gold Rush, the California Native Americans, like this chieftain, were a robust, healthy people. Their idyllic existence changed quickly. The 'niners and the natives sometimes clashed. Fore example, in April 1849, John Ross left five fellow miners on the Middle Fork of the American River while he went to Coloma for supplies. When he returned, the miners had been killed. A posse of some 20 young vigilantes blamed the natives and rode to a nearby village, where they killed several Nisenan natives, destroyed the village, and returned to Coloma dangling scalps. The group then captured about seven villagers near Weber Creek, brought them back to Coloma, and killed them. Marshall tried to intervene, but the intoxicated crowd and local Nisenan villagers turned against him, and he was forced to leave the area. (Courtesy of the California State Library, Sacramento, California.)

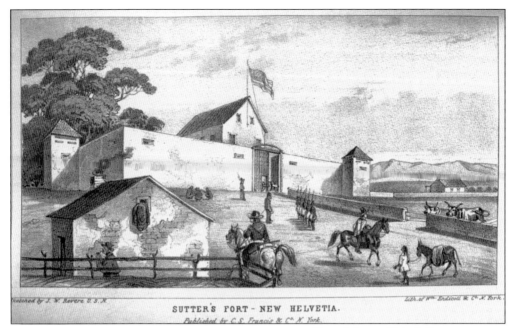

SUTTER'S FORT - NEW HELVETIA.

Sketched by J. W. Revere U.S.N. Lith. of Wm. Endicott & Co. N. York.

Published by C. S. Francis & Co. N. York.

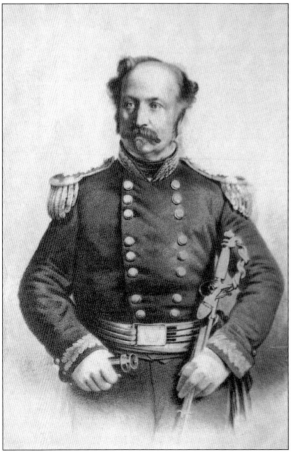

Capt. Johann (John) Sutter built this adobe-walled fort at the junction of the Sacramento and American (Rio Americano) Rivers. Wagon trains stopped here after struggling west over the Sierra Nevadas. Sutter called his thriving outpost New Helvetia, honoring his native Switzerland. The fort had a population of 250 whites, 450 natives, and Sutter's workers (Kanakas) from Hawaii. (Courtesy of the California State Library, Sacramento, California.)

In spite of his ornate military uniform, Captain Sutter was not really a captain. Fleeing debtors, he left behind a wife and five children in his native Switzerland to seek his fortune in America. He had big dreams of carving out a vast empire in the wilderness of the Central Valley. The Gold Rush, however, derailed his hopes for a California fiefdom. (Courtesy of the California National Guard.)

Born in 1810, James Wilson Marshall left his New Jersey home in 1834 and reached Sutter's Fort in 1845 by way of Missouri and Oregon. John Sutter welcomed the carpenter and blacksmith, partnering with him to supervise construction of the sawmill in Coloma. (Courtesy of the California State Library, Sacramento, California.)

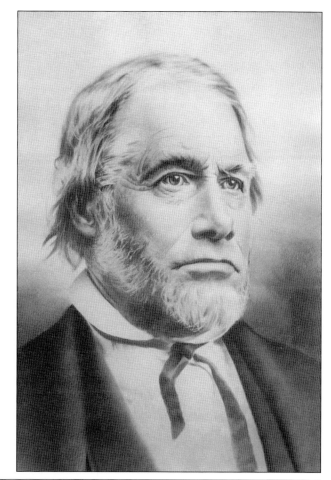

Using colored pencils, Marshall drew this crude map of Sutter's Mill and the surrounding valley in 1850. Dutch Creek is noted at the lower left, and the mill is in the center. Stands of pines, most of which were cut down within just a few years, surround the mill. (Courtesy of the California State Library, Sacramento, California.)

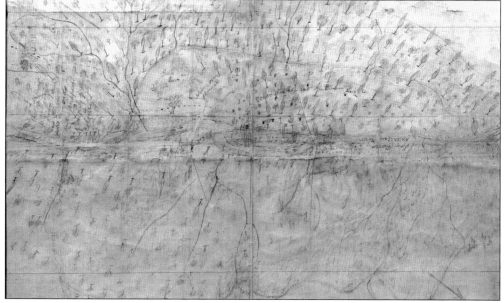

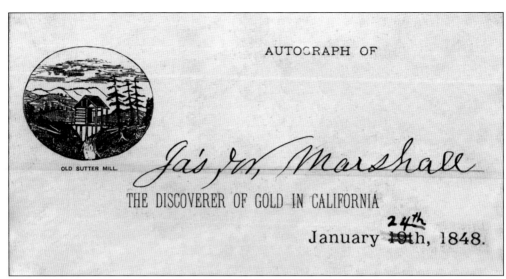

AUTOGRAPH OF

OLD SUTTER MILL.

Jas, W, Marshall

THE DISCOVERER OF GOLD IN CALIFORNIA

January ~~19~~th, 1848.
24th

Marshall signed many of these cards, noting the gold discovery date as January 19. The actual date has been the subject of controversy over the years. In 1919, the California Legislature officially set the date as January 24. Much else is controversial, too, including whether it was Marshall or someone else who actually found the first gold. (Courtesy of MGDSHP.)

Sam Kyburz, photographed here in old age, was employed as a superintendent at New Helvetia (Sutter's Fort). Accompanied by a German millwright named Jacob Ginery, Kyburz led a group to the mountains to find a sawmill site. Although Marshall is credited with finding the Coloma Valley, some sources indicate Kyburz was the discoverer. (Courtesy of the California State Library, Sacramento, California.)

In 1846, Sam Brannan arrived in Yerba Buena (renamed San Francisco in 1847) with a printing press and about 240 other members of the Church of Jesus Christ of Latter-day Saints. He established California's second newspaper, the *California Star*, and later opened a store at Sutter's Fort. One of the first to hear about the gold discovery, he promptly purchased some $12,000 worth of mining supplies, creating shortages, and made a fortune. (Courtesy of the California State Library, Sacramento, California.)

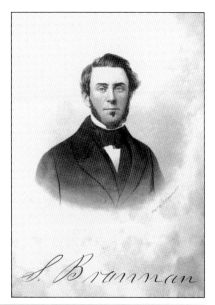

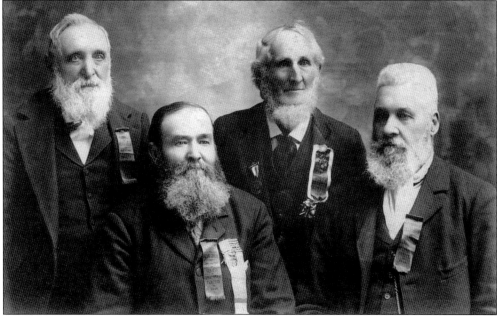

Photographed at the 1898 Golden Jubilee in San Francisco—the 50th anniversary of the Gold Rush—are four individuals who witnessed the gold discovery. They were members of the Mormon Battalion, a group of 536 saints commissioned by Brigham Young and President Polk to provide defense in the Mexican War on their journey west escaping religious persecution. When the battalion avoided action with Mexican soldiers, it was charged by wild cattle. In the fray, two saints and mules were injured, and several bulls were shot. The stalwart battalion continued the longest infantry march in US history, traveling halfway across the country in 1847. It mustered out at Los Angeles. A few of the men drifted to Sutter's Fort and were on hand when gold was found; they donated over $17,000 in gold to the Latter-day Saints' new home. Shown from left to right are Henry W. Bigler, William J. Johnston, Azariah Smith, and James S. Brown. (Courtesy of Jeff and Barbara Lee.)

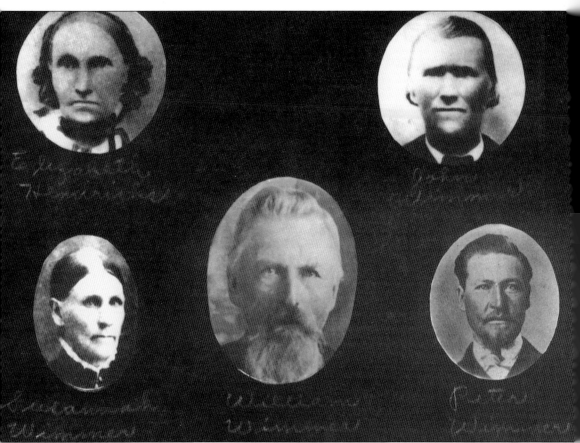

In 1844, Peter Wimmer, a widower with five children, married widow and mother of two Elizabeth Jane Cloud Baiz, also called Jennie, and they crossed the plains and mountains by wagon train to Sutter's Fort in 1846. At the mill in Coloma, Peter oversaw the Indians, and Jennie cooked for 10 to 15 men. A veteran of Georgia gold mining, she dropped Marshall's nugget into a kettle of lye soap to prove the metal was indeed gold. (Courtesy of MGDSHP.)

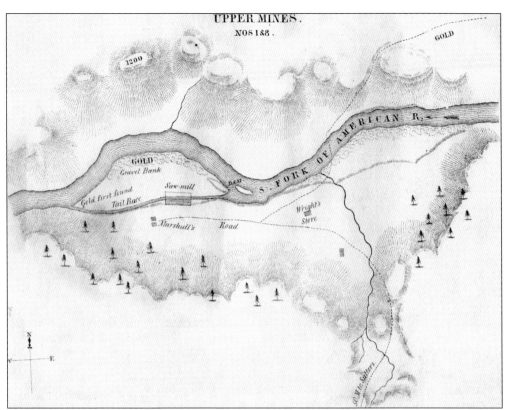

Col. Richard Barns Mason, the first military governor of California, heard about gold at Sutter's Mill and traveled there in June 1848 with then–chief of staff William Tecumseh Sherman. In the Civil War, General Sherman plotted the Union army's devastating march from Atlanta to the sea to force an end to the war. Sherman drew this map of the South Fork of the American River in Coloma. They estimated that half of the 4,000 miners working in the valley were Native Americans. (Courtesy of Jeff and Barbara Lee.)

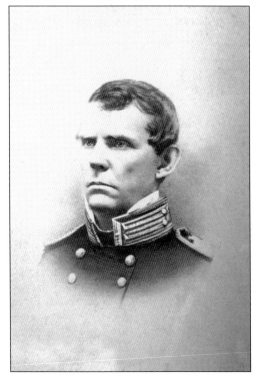

Col. Richard Barns Mason, here resplendent in his uniform, dispatched courier Lt. Lucian Loeser on August 30 to Washington, DC. Loeser arrived in late November, presenting President Polk with convincing evidence of gold in the hills of California: 230 ounces. The Gold Rush officially commenced. Mason died of cholera near St. Louis in 1850. The disease killed thousands in Gold Rush California. (Courtesy of the California State Library, Sacramento, California.)

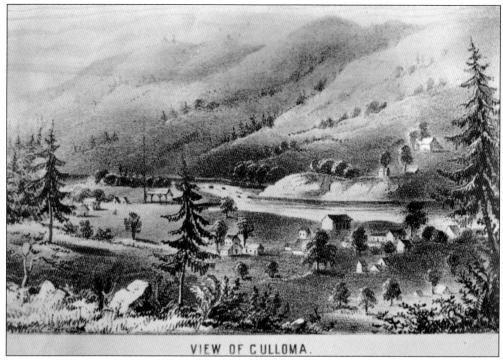

VIEW OF CULLOMA.

By early 1849, Culloma, as it was then called, consisted of only a few scattered buildings. This view, facing north, shows Sutter's Mill on the left and a few larger buildings on the right. The site would become the heart of the town in just a few short months. (Courtesy of the California State Library, Sacramento, California.)

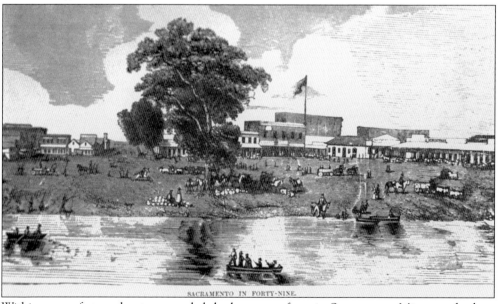

SACRAMENTO IN FORTY-NINE.

Within a year, fortune hunters crowded the busy waterfront in Sacramento. Miners and others squatted on Sutter's land, eventually causing him ruin. Almost overnight, Sacramento became a jumping-off point to Coloma and other gold-mining towns. (Courtesy of the California State Library, Sacramento, California.)

Two

QUEEN OF THE MINES

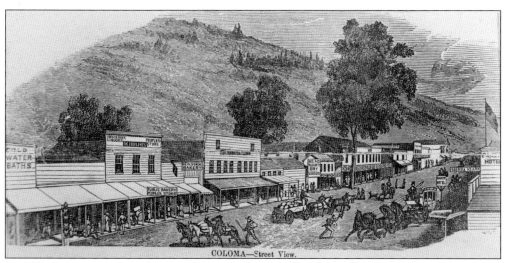

COLOMA—Street View.

By 1853, Coloma was flourishing, with many substantial buildings. This sketch shows Main Street facing southwest from Piety Hill, where the schoolhouse now stands. Coloma merchants peddled luxuries great and small. Miners spent lavishly on cigars, daguerreotypes, candy, jewelry, books, and overpriced groceries and mining equipment. Gamblers and prostitutes also parted argonauts from their hard-won gold. Fresh oysters and other viands took places of honor on hotel menus. (Courtesy of the California State Library, Sacramento, California.)

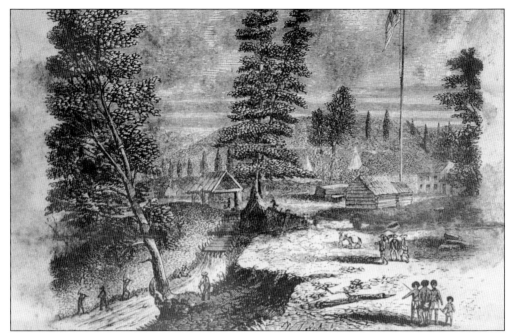

At first, Coloma wasn't much of a town. By early spring in 1849, it consisted of perhaps three to eight structures plus the sawmill, inoperative for a while. In this sketch, local Nisenan people look on. Mill operations were resumed in March 1849 for a short time, and the number of wood buildings doubled. (Courtesy of the California State Library, Sacramento, California.)

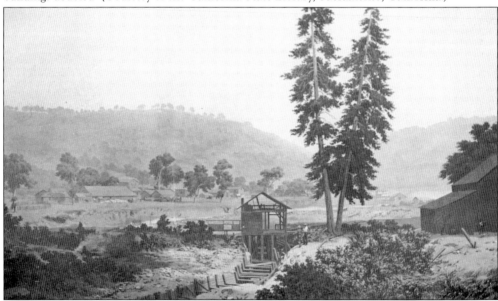

Noted Gold Rush artist Charles Nahl created this image of Sutter's Mill soon after he arrived in California. Revived for a while because of the demand for lumber, the mill operated off and on for only 30 months. Miners stole metal and lumber. Entrepreneurs created souvenir canes using dismantled parts of the building, selling them for up to $12. In the 1850s, floodwater completed the demolition of the historic structure. (Courtesy of the California State Library, Sacramento, California.)

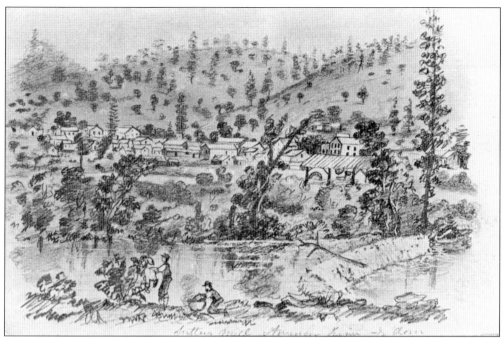

In this typical early-day Coloma scene, miners dam the river in the foreground trying to get at gold-bearing gravels. In 1848 and early 1849, few Coloma businesses were located near the sawmill. By mid-1849, the town had expanded greatly, with many buildings on both sides of the river. (Courtesy of MGDSHP.)

Arriving in Coloma on April 1, 1849, John Little soon built Coloma's largest store, located on the north side of the river. It measured 160 feet by 80 feet and cost $20,000. He quickly built five additional stores in the Gold Country. The same year, he grudgingly became Coloma's first postmaster. In the summer of 1850, Little built Coloma's first bridge. (Courtesy of the California State Library, Sacramento, California.)

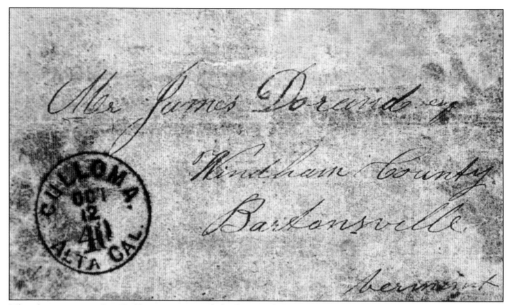

This letter carried a Culloma postmark before California was a state. Six Pony Express riders shuttled mail between Coloma and surrounding mines, charging $1 per letter for delivery. A local newspaper, the *Empire County Argus*, reported in 1854 that over 4,000 letters and packages left Coloma for the Atlantic states. Because of the nomadic nature of the miners, many dead letters were returned by wagon to San Francisco. (Courtesy of MGDSHP.)

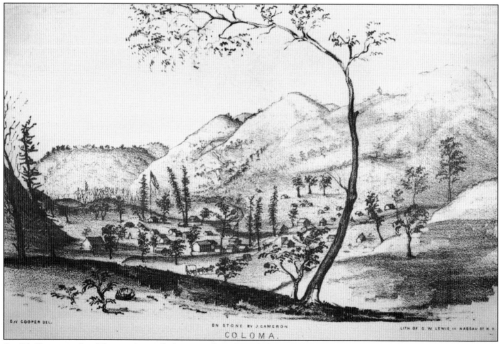

In 1849, town buildings dotted the north side of the river, including John Little's store. Little also owned an adjacent hotel. The Sunday menu tempted patrons with delicacies such as boiled salmon and green peas, ham, corned beef, mutton, roast venison, veal, apple and peach pie, and rice pudding. (Courtesy of the California State Library, Sacramento, California.)

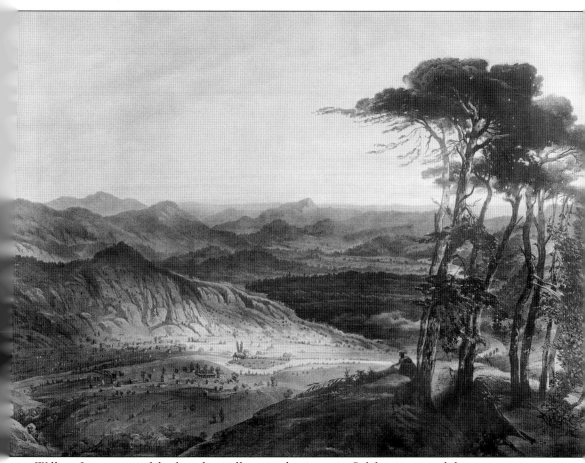

William Jewett, one of the first classically trained painters in California, created this panoramic, slightly fanciful lithograph in 1850 for his friend, storekeeper and postmaster John Little, showing Coloma from the summit of Mount Murphy. Little sold copies of the lithograph as souvenirs from his various stores. Patrick O'Brien Murphy built a small fort on top of Mount Murphy, complete with a cannon, to protect himself from Indians, unaware that local Native Americans were peaceable. Finding no human targets, the story goes he instead used the cannon to signal the arrival of the mail stagecoaches. In later years, Jewett made a fortune in California real estate. (Courtesy of MGDSHP.)

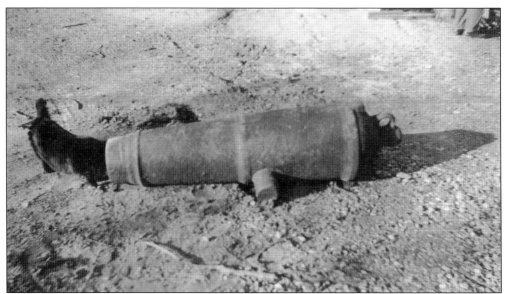

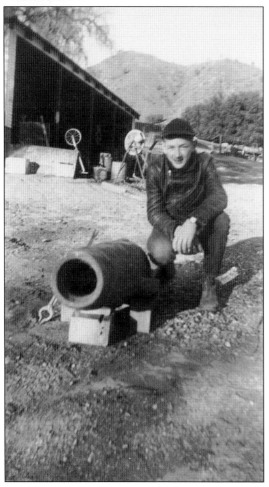

A curious cat examines the business end of this historic cannon (possibly the same cannon placed on Mount Murphy and mentioned on page 25), which today is mounted in front of the Coloma Community Hall. John Sutter may have purchased the cannon, likely made between 1790 to 1820 by Carron Iron Works in Scotland, for his fort from Fort Ross, a Russian outpost on the Northern California coast, or from the Sandwich Islands (Hawaii). In Coloma, folks fired it on all manner of occasions. In 1858, while honoring Andrew Jackson's Battle of New Orleans (or perhaps Governor Weller's inauguration), the cannon accidentally killed a man named Spencer. (Courtesy of MGDSHP.)

Townspeople then spiked this cannon and buried it muzzle-down in front of the Sierra Nevada Hotel. When that building burned, they moved it to the schoolhouse. However, the cannon disappeared in about 1940. In 1949, it reappeared in a Loomis field. Byron Bacchi and Ray Lawyer brought the cannon back, restored it, and fired it in Coloma in January 1950, creating a commotion. Here, Byron's son, rancher Ed Bacchi, poses with the cannon. (Courtesy of Bill Bacchi.)

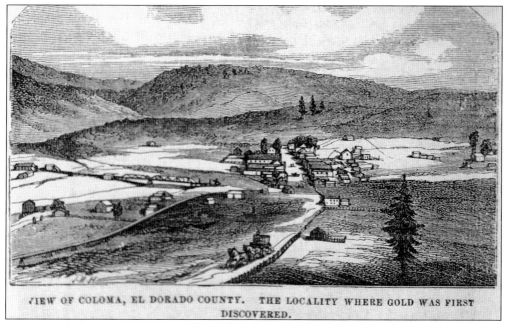

VIEW OF COLOMA, EL DORADO COUNTY. THE LOCALITY WHERE GOLD WAS FIRST DISCOVERED.

A stagecoach charges out of town in this 1850s lithograph of Coloma's main road. In 1849, James E. Birch inaugurated the first stage line between Sacramento and Coloma via Mormon Island. He sold the line in May 1851, headed east to marry, and returned in 1853. Other stage companies quickly filled the transportation void. (Courtesy of the California State Library, Sacramento, California.)

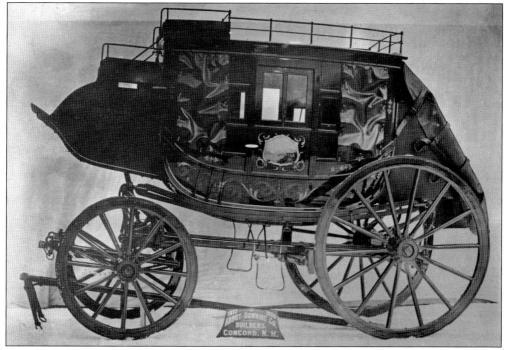

By 1853, Coloma stage companies featured splendid Concord stagecoaches, considered the finest road vehicles of their time. The stage lines linked Sacramento, Georgetown, Auburn, and points beyond. In all, about 14 stagecoaches arrived each day in Coloma. (Courtesy of MGDSHP.)

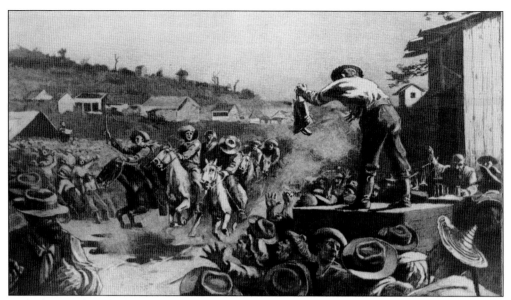

Early diarists described wild men and wild times. Most gold miners were men under the age of 30, and many were away from home for the first time in their lives. Some were escaping poverty, while others fled dreary lives. In this depiction of Coloma, frenzied horsemen disrupt an outdoor auction. (Courtesy of the California State Library, Sacramento, California.)

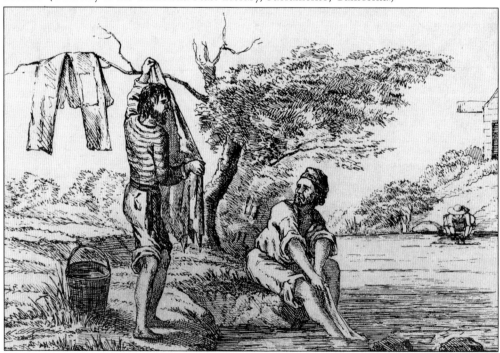

This sketch depicts miners doing laundry at the river's edge. Often they stood in water for hours mining gold, and many slept wearing wet boots. Hygiene was dubious. More affluent miners stayed at hotels and paid well to share bath water with several other miners. The lifestyles presented serious health risks. Medicine was primitive. Cholera outbreaks decimated the mining towns. Later, Chinese immigrants took over many laundry duties. (Courtesy of MGDSHP.)

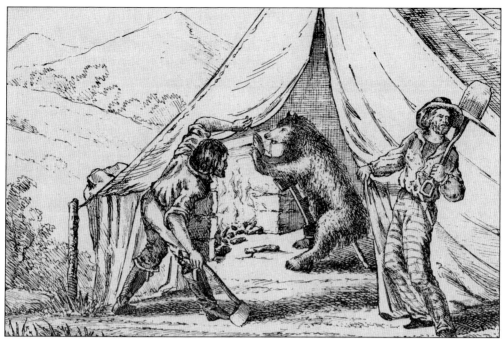

A bear warms itself at the miners' fire in this humorous sketch. Both grizzly and black bears were common in California during the Gold Rush, but the influx of humanity doomed the grizzly bear in California. Ironically, even though the animal appears on the state flag, grizzly bears have not lived in California since the early 1920s. Black bears still occasionally wander through the valley. (Courtesy of MGDSHP.)

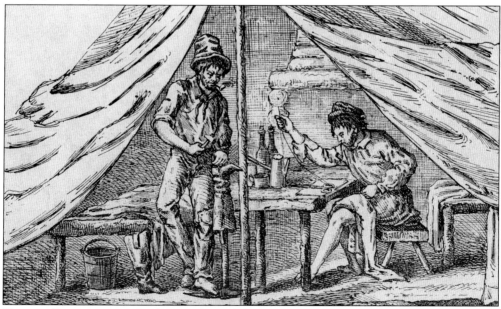

Historically women's work, the mending of clothing fell to men when their womenfolk were thousands of miles away. Nutrition and health typically were disregarded in the relentless quest for gold. Scurvy plagued the miners, resulting from a local diet of hard tack and salt pork. (Courtesy of MGDSHP.)

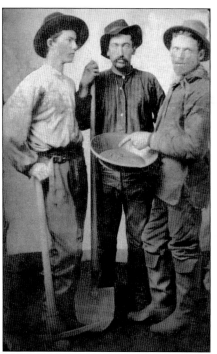

Young miners (left to right) Daniel Teuscher, Joseph Papini, and Philip Teuscher pose with a pick, shovel, and gold pan. Philip, pointing out a few choice nuggets, is also depicted on the cover of this book. He served as the second custodian of Marshall Monument in the 1890s. All three men settled in the area, and Papini's descendants still live in Coloma. (Courtesy of Rita Archie, Philip Fancher, and Vickie Longo.)

In this depiction, miners prepare a simple meal in camp. When gold was discovered, hundreds of ships were abandoned in San Francisco Bay as crews rushed to the goldfields. Tents like the one shown here were often made from ship sails. Although Coloma was the commercial and social center of the region, countless mining camps existed nearby. By 1849, hundreds of tents whitened the landscape in the Coloma Valley. (Courtesy of MGDSHP.)

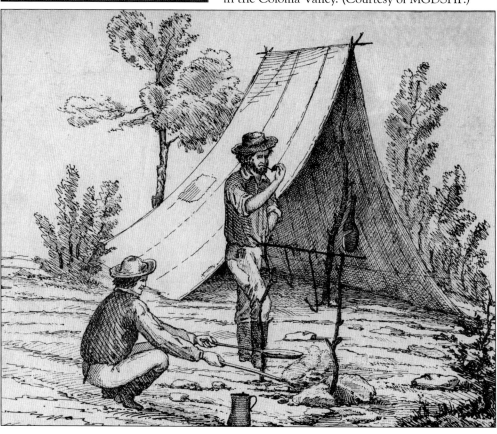

Gambling was a favorite pastime among miners. This sketch depicts a card game known as monte. Faro was another popular card game. By 1850, gambling palaces were opulently furnished. The Winters Hotel in Coloma, for example, featured large gold-plated chandeliers, several monte tables, and four faro tables. (Courtesy of MGDSHP.)

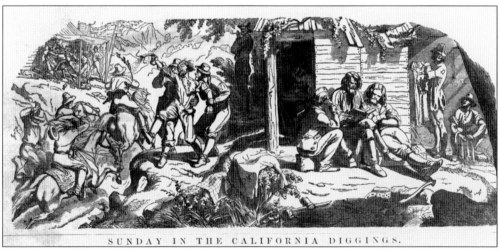

SUNDAY IN THE CALIFORNIA DIGGINGS.

The antics and roguery that prevailed in most mining camps occasionally gave way to days of calm and rest (or recovery). Gold Rush artist Charles Nahl created this drawing for the magazine *Wide West Illustrated*, later developing the sketch into one of his most famous paintings, *Sunday Morning in the Mines*. Miner Nathan Kays wrote in 1851, "People live more like hogs than human beings." (Courtesy of the California State Library, Sacramento, California.)

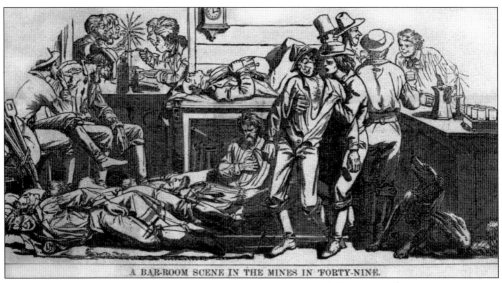

A BAR-ROOM SCENE IN THE MINES IN FORTY-NINE.

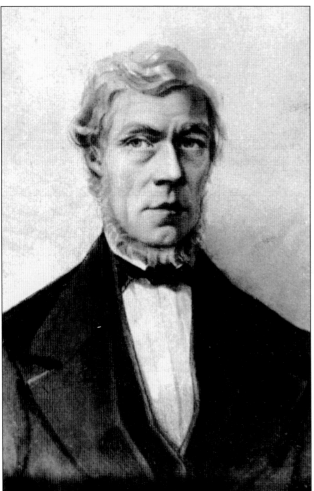

Miners were known to get drunk and unruly. Early-day diarists contended that Coloma remained relatively peaceful, while others reported frequent gunfights. "Justice" was meted out quickly. Hangings were common, some becoming public spectacles. A famous double hanging took place in Coloma in 1855, attracting more than 5,000 people. Schoolteacher Jeremiah Crane was hanged for murdering a young female student with whom he had had an affair. At the same event, ne'er-do-well Mickey Free was hanged for murdering several miners. (Courtesy of the California State Library, Sacramento, California.)

Shown here is Frank Bekeart's father, Philippe, who was born in France. Philippe lived in London with his family before he immigrated to New York in 1836. At the age of 15, his son Frank (born Jules François) was apprenticed to a gunsmith, a trade Frank followed in Coloma until his retirement in 1890. (Courtesy of MGDSHP.)

Frank Bekeart, born in London in 1822, became one of Coloma's most prominent citizens. With a consignment of 200 Colt Patterson revolvers and 200 Allen's Pepper Box revolvers, young Bekeart left New York for California via Panama in 1848. Within a few days of arriving in Coloma, he was collecting over $100 a day in gold dust from miners in need of his gunsmith services. Early on, he helped lay out the town of Coloma, and he built the stout brick store that still survives. (Courtesy of MGDSHP.)

Frank Bekeart's gun shop has changed little since this 1914 photograph, except the family residence directly behind the store is long gone. In Coloma's early days, the gun shop was one of the few brick structures in town, situated on the north side of Main Street and adjacent to Bridge Street. The fig tree, planted by Bekeart's wife, Mary Craddock Bekeart, still thrives. (Courtesy of MGDSHP.)

Herman Au produced the first official map of Coloma buildings in 1857. Au was born in Germany in 1826 and graduated from Heidelberg University, majoring in music, languages, and civil engineering. In 1857, Au and his sister came to Coloma, where he taught music. (Courtesy of MGDSHP.)

Because of Herman Au's detailed map, historians have a better idea of the layout of Coloma at its peak in 1857. Today, interpretive signs throughout the historic town rely heavily on this information. (Courtesy of MGDSHP.)

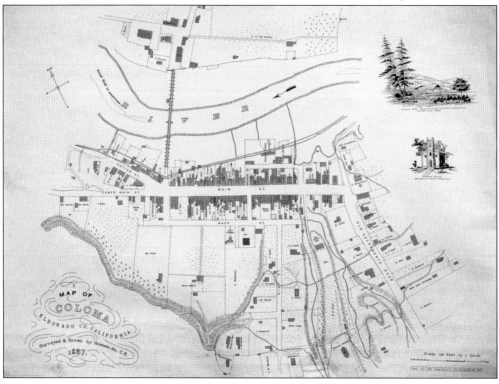

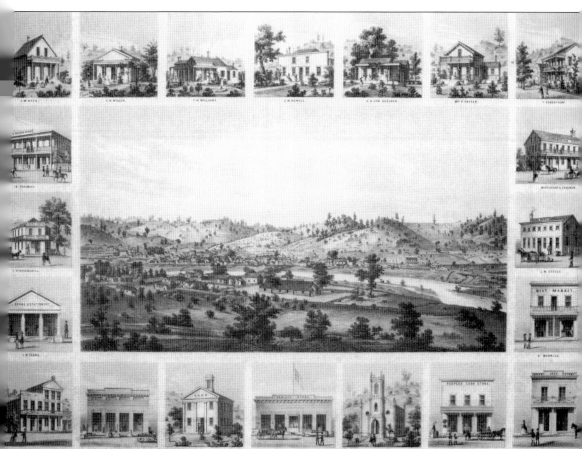

This 1857 lithograph by Kuchel & Dresel provides the only visual record of some of the most prominent early buildings in Coloma. For example, it shows the Wintermantel's Miner's Hotel, a grand, wedge-shaped hostelry built in 1849. Today, the Coloma Community Hall occupies the site. The center image shows Coloma as seen from the north side of the river. John Little had a store, post office, and hotel here. (Courtesy of MGDSHP.)

The sturdy stone Coloma jail, completed in 1856, replaced a log jail built about 1850. Hangings were common, including a botched 1854 hanging by Sheriff David E. Buel when the knots slipped on two criminals; they survived, at least for a few minutes. Justice sometimes took a quirky turn: in a case involving two women, a Mrs. Brown used bad language toward a Mrs. Murphy and hit her over the head with a chicken. Brown was fined $20 and court costs of $7.90. (Courtesy of the California State Library, Sacramento, California.)

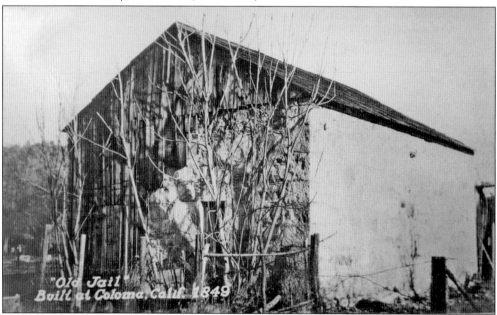

The jail (misdated in this image) was used only briefly. When the county seat moved from Coloma to Placerville in 1857, the jail fell into disrepair, and many of the massive stones—quarried in nearby Gold Hill—found their way into other Coloma buildings, including the Vineyard House. Some large timbers were used in the construction of the Williams-Markham House. (Courtesy of the California State Library, Sacramento, California.)

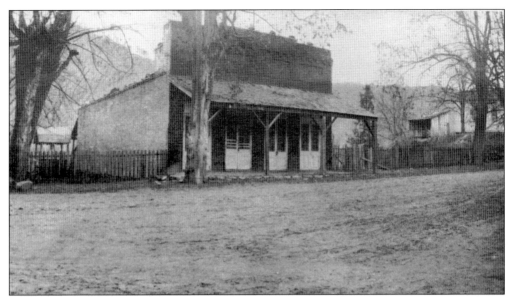

Remains of the Bell and Allen Store, built of brick in the mid-1850s, endure today. This image was made before 1919. During the Gold Rush, profiteering was widespread. Bread sold for $2 a pound, and butter was $6 a pound. Ale cost $8 per bottle, and eggs were 50¢ each. Potatoes sold for 50¢ per pound. A gold pan and pick—essential for gold mining—sold for a whopping $160! The building shown here later became Coloma's post office. (Courtesy of MGDSHP.)

The Weller house, built on the site of the Orleans Hotel and a theatre, belonged to merchant Elias Weller, who purchased the building around 1865. The Orleans Hotel advertised in the *Coloma Argus* newspaper in 1853 good substantial foods, appealing to "Old Customers, etc. Oysters and Ham and Eggs. Served up at all hours." Pictured from left to right are an unidentified driver, Abe Borland, Elias Weller, Mrs. Weller, Kate Weller, and Charles Weller. (Courtesy of MGDSHP.)

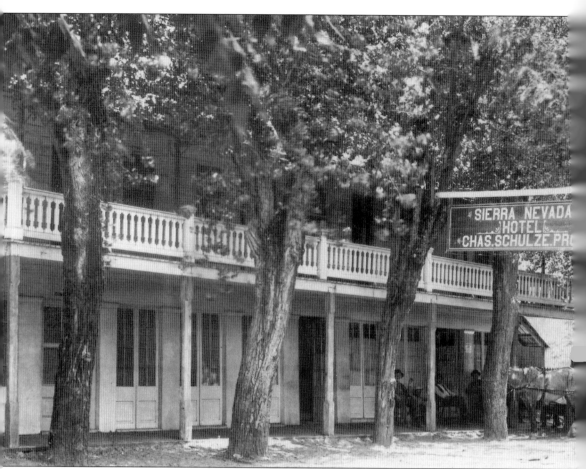

Philip Schell built the Sierra Nevada Hotel in 1850. In 1852, Robert Chalmers acquired it, and he greatly expanded it after his purchase. He ran it until about 1865, when his sons Hugh and Abe became managers. It burned in 1902. In 1886, Charles Schulze married a widow, Mrs. Anderholden, who owned the hotel. Schulze owned the Sierra Nevada Hotel from the 1880s until his death in 1921. The hotel was noted for its excellent food and music. Grand balls, cotillion parties, assemblies, suppers, and special celebrations took place in the spacious structure. In an 1856 letter, Catherine Ferrier Chalmers, first wife of Chalmers and mother of six of his children, wrote, "I am very tired of public life and long to be in a house by myself. There is not much help and 70 or 80 people sit down to the table every meal, so our house is in constant commotion from morning til night. When court is in session we are all the busier." She died of consumption in 1857. (Courtesy of MGDSHP.)

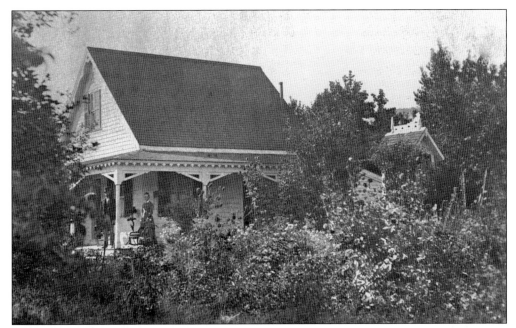

Carpenter John Storer built this house—at first a simple one-story home—for Hugh Miller in 1852. Later, the Norris family, who maintained an orchard in the valley, lived here. In the 1960s and 1970s, it was the home of famed Gold Rush artist George Mathis, who maintained a studio on the first floor. Still later, the building became a bed-and-breakfast inn. The first Coloma jail, built of logs, was nearby. (Courtesy of MGDSHP.)

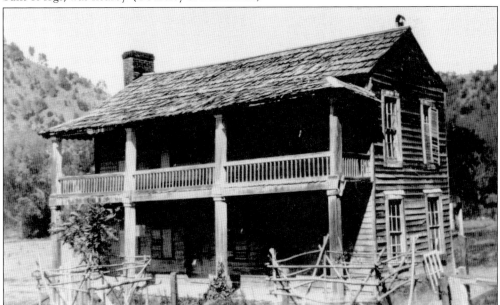

This home near the courthouse belonged to Col. Thomas Robertson. He also owned the nearby Alhambra Saloon. Robertson, a fine orator, maintained one of Coloma's first law offices next to the Orleans Hotel with his partner, John Hume. A founding member of the local Masonic Acacia Lodge, the attorney was elected to the state assembly on September 7, 1859. He died, however, on October 2, 1859. Later, the Almstaldens owned the home. (Courtesy of MGDSHP.)

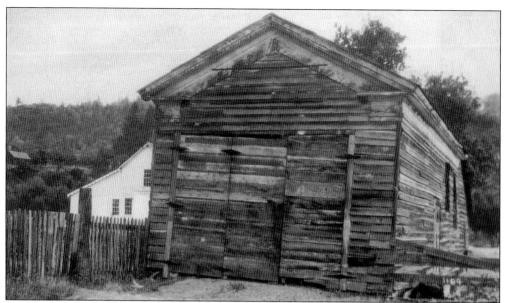

This small building served as the armory of the Coloma Grays (Greys), organized as a military company around 1852. A.A. Van Guilder, a lawyer and Coloma merchant, served as captain. The company disbanded about 1855 because of internal dissension but reorganized in 1857 with John Vanderheyden, a saloon owner and fruit grower, as captain. The group was noted more for dances and parades than for fighting. Four of the Grays fought in the Union army during the Civil War. (Courtesy of MGDSHP.)

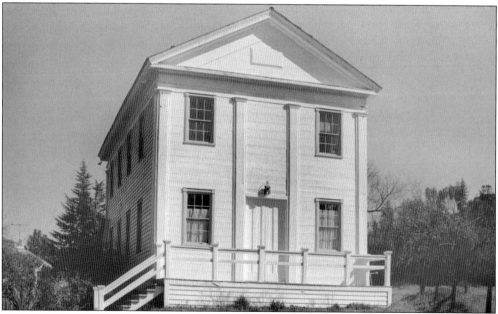

The IOOF (International Order of Odd Fellows) Hall is a Coloma landmark. Pioneer blacksmith J.C. Brown, active in business, political, and social affairs, helped organize and build the lodge in August 1854. In addition to housing the IOOF, the building was used as a joint Baptist and Methodist Sunday school. It also briefly served as a schoolhouse in the 1870s and after the first Coloma school burned in 1919. (Courtesy of MGDSHP.)

Erastus Woodruff, an attorney with the firm Woodruff and Stevenson, owned a store and hotel on the north side of the river. A major landowner, he planted one of the first orchards on the north side of the river in the 1850s and had 16 acres of vineyards. (Courtesy of MGDSHP.)

This view of Coloma from the early 1900s shows the second Sierra Nevada Hotel, lower left, before it burned. The old schoolhouse, formerly the courthouse, can be seen in the lower center. Just to the right is the Murphy home, at the time the home of a Mrs. Elge. The Alhambra Saloon once stood between the two buildings. In 1850, it was the great hold out of gamblers, all kinds of games constantly in progress. By 1855, it featured the choicest liquors and cigars on hand and a fine billiard room. (Courtesy of Rita Archie, Philip Fancher, and Vickie Longo.)

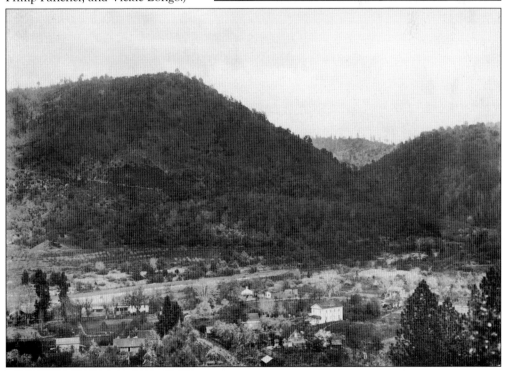

Aound 1913, Annie Elgie (Elge) reposes in her tiny parlor in the Papini House. On this site in 1853, Luther Davis built an elegant two-story bakery and confectionery shop. In addition to making fresh bread daily, he advertised "cough candy manufactured from Iceland moss" and wedding cakes "fronted and trimmed in elegant style." He even sold ice cream in the summer. Joseph Papini built the current cottage in 1890. (Courtesy of Rita Archie, Philip Fancher, and Vickie Longo.)

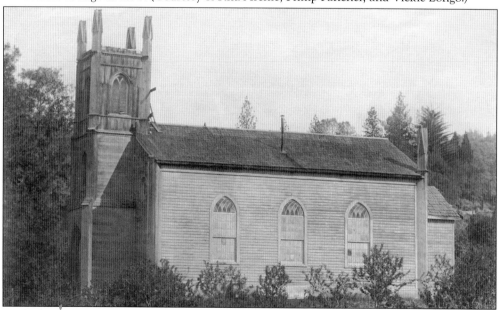

By the late 1890s, the Emmanuel Church was in dire need of a paint job. The Coloma Methodist Episcopal Church was organized in 1850. Construction of the church began in 1855 and was completed in 1856 at a cost of $7,000. The church, founded by the Reverend William J. Kipp, was the first Protestant church in the Gold Country. (Courtesy of MGDSHP.)

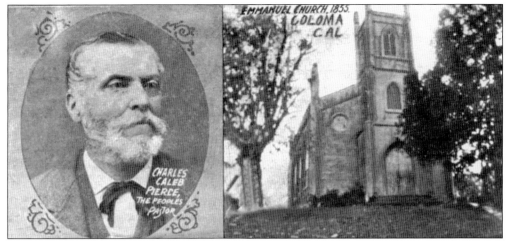

A souvenir tray depicts the Emmanuel Church together with a portrait of the Reverend Caleb C. Peirce (also known as Charles Caleb Pierce), a circuit preacher who served the church from the 1860s through the 1880s. In 1921, the church became the property of the Methodists, who made extensive improvements. The church became state park property in 1963. (Courtesy of MGDSHP.)

Christmas decorations crowd the Emmanuel Church. During the Gold Rush, worshippers faced competition. As Nathan Kays wrote in 1851, "In this place [the church] is occasionally preaching, the congregation is always small and not 20 steps from the church are some three or four houses with a number of gaming tables surrounded by hundreds who are participating in the vices of gambling and drinking." (Courtesy of MGDSHP.)

Tiny Catholic St. John's Church was first incarnated as a log building in 1850. The present church was finished in 1858. In the 1970s, Coloma resident Florence Fannen spearheaded a restoration of the building, and now the property belongs to the State of California. Participating in a fundraiser, actor George Burns, whose daughter owned a nearby resort, purchased a plaque honoring his late wife, Gracie Allen. It reads, "Say goodnight, Gracie." Today, weddings occasionally take place in the little church. The cemetery behind the church contains remains of some of Coloma's most prominent pioneers. Close by is James Marshall's cabin. (Courtesy of Rita Archie, Philip Fancher, and Vickie Longo.)

Three

GRUBBING FOR GOLD

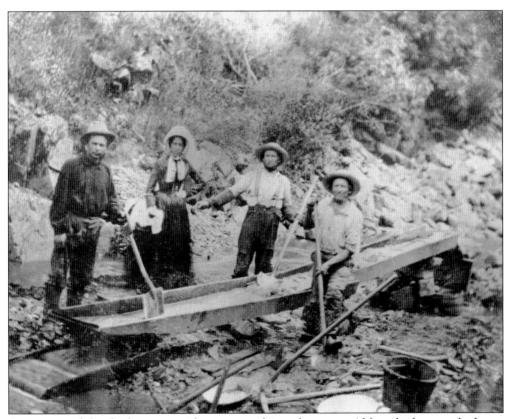

A woman with her basket poses with miners working a long tom. Although photographed near the Auburn area, a few miles north of Coloma, this scene could have been anywhere in the Coloma vicinity. Women were rare in the mines during the early years of the Gold Rush. Later, some men brought their families or went back home, found brides, and returned with them to California. (Courtesy of MGDSHP.)

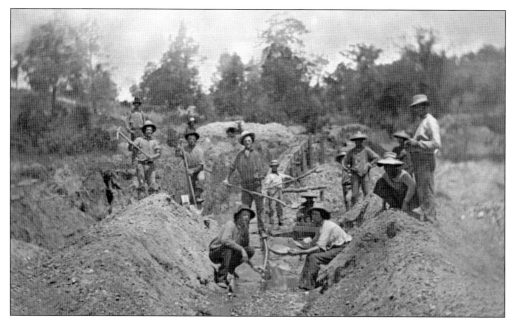

Preserved by the Bekeart family, this daguerrotype of mining near Coloma shows a sluice and considerable gold in the pan. Martin Allhoff, later a noted Coloma vintner, stands with his shovel in the center of the image. To the right, Chinese workers await instructions. In the mines, they did a lot of the heavy manual labor. (Courtesy of MGDSHP.)

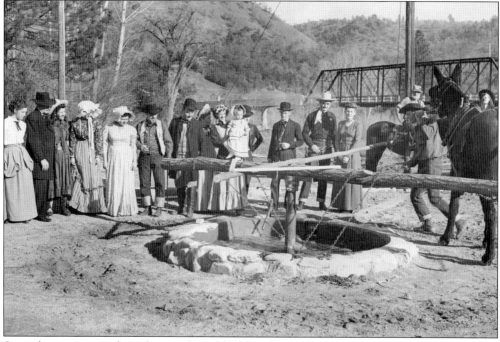

Spanish was commonly spoken in the goldfields. Thousands of miners from Mexico (primarily Sonora) and Chile, along with native Californians, searched for gold. Here, at the 1948 centennial celebration, volunteers demonstrate a Mexican *arrastra*. Mules or horses pulled large rocks around a circular depression, pulverizing the rocks to get at gold. (Courtesy Barbara Wagner Veerkamp.)

One of the more popular techniques for getting to placer (surface) gold involved using a rocker. Miners dumped gravel in the top, then removed large pieces. They then used water to sluice smaller gravel and sand through the holes in the rocker, all the while gently rocking the contraption. Riffles or slats at the bottom collected the heavy gold and iron, which miners carefully panned. According to some sources, Isaac Humphreys, a Sutter's Fort worker, brought the first rockers in the goldfields to Coloma. (Courtesy of the California State Library, Sacramento, California.)

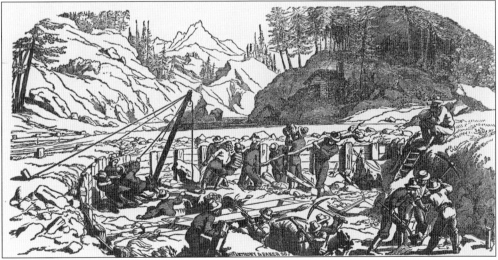

Because gold is so heavy, it typically sinks to the bottom of rivers and streams. Miners built small dams to hold back the water so they could work the floors of watercourses. The Chinese were particularly adept at this technique, constructing "wing dams" up and down the Coloma-Lotus Valley. (Courtesy of the California State Library, Sacramento, California.)

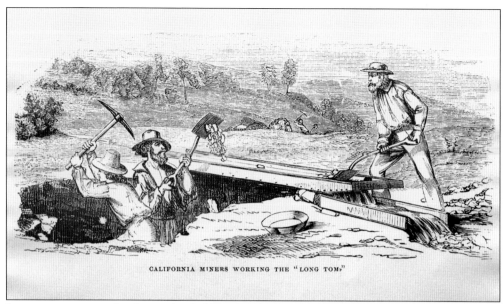

CALIFORNIA MINERS WORKING THE "LONG TOM."

Long toms were popular during the Gold Rush. They consisted of a long wooden trough through which gravel was sluiced with water. Later, miners used dredgers up and down the Coloma-Lotus Valley. Dutch Creek, on the north side of the river, was pummeled by hydraulic mining: with this technique, miners could wash away whole hillsides using huge high-pressure nozzles. (Courtesy of the California State Library, Sacramento, California.)

Miners worked long toms well after the Gold Rush near the site of Sutter's Mill. Although miners removed most of the easy placer (surface) gold during the Gold Rush, mining continued into the 20th century. Today, visitors still enjoy panning for gold in Coloma. (Courtesy of MGDSHP.)

In this sketch, a Chinese miner heads for the mines. An influx of Chinese immigrants swelled in 1852 during a severe drought in China. American miners often hired Chinese workers to deliver bags of supplies between the mining camps. The relationship between Chinese and other miners was strained. To avoid conflict, the Chinese worked less productive claims. (Courtesy of the California State Library, Sacramento, California.)

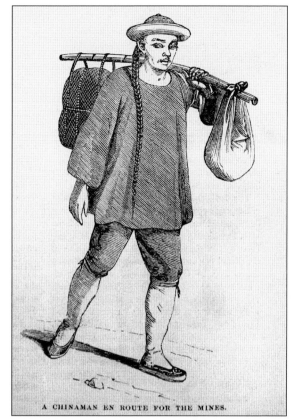

A CHINAMAN EN ROUTE FOR THE MINES.

This sketch depicts a Chinese miner operating a rocker to get at the placer gold. The Chinese followed in the footsteps of the more impatient American miners, often carefully reworking abandoned claims. The Chinese called California *Gam Sam*, which translates to "Gold Mountain." About 20,000 Chinese immigrants flocked to California during the Gold Rush. (Courtesy of the California State Library, Sacramento, California.)

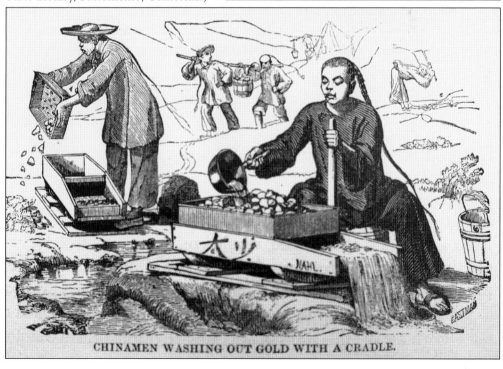

CHINAMEN WASHING OUT GOLD WITH A CRADLE.

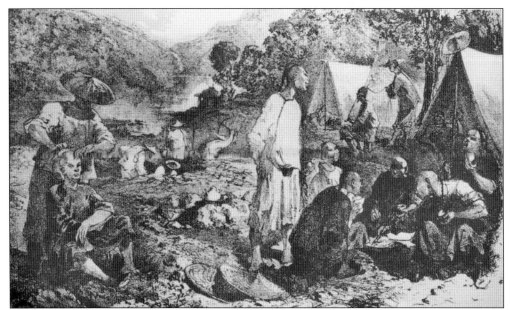

Chinese camps flourished throughout the Gold Country, although the Chinese found life hard. There were few Chinese women, and of those most were prostitutes. In May 1852, the state imposed a Foreign Miners Tax—mostly directed at the Chinese—of $3 to $4 per month. By 1877, 63,000 Chinese immigrants lived in the United States, 77 percent of whom were in California. The tax totaled more than $5 million, almost one quarter of the state's revenue. (Courtesy of the California State Library, Sacramento, California.)

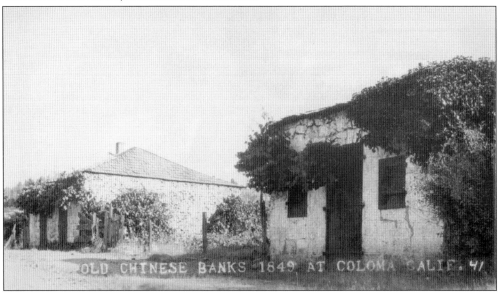

About all that remains of the Chinese legacy in Coloma are these two stone stores, once in Coloma's Chinatown. The Man Lee and Wah Hop stores were built about 1856 and restored in the 1940s. They sold everything from peanuts to Chinese brandy. Artifacts for the present-day Wah Hop store interior came from the town of Newcastle in Placer County. Wong Poon Shek owned the Newcastle buildings, which were demolished in 1958 when Interstate 80 was constructed. (Courtesy of MGDSHP.)

Eadweard Muybridge was born in England and extensively photographed the American West. He later became known for his motion photography experiments using the zoopraxiscope. In this 1852 image, he portrayed what he called a "heathen chinee" gold panning. A large sluice is barely visible in the background. (Courtesy of the California State Library, Sacramento, California.)

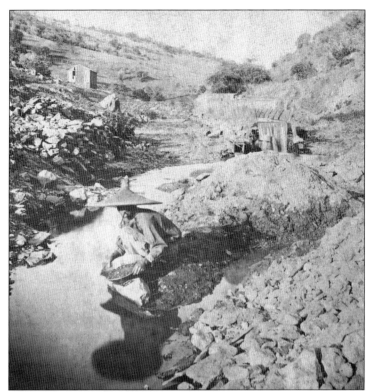

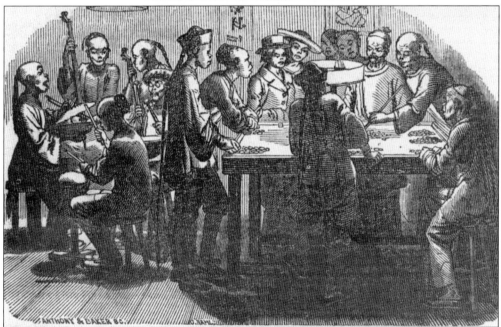

The Chinese brought with them a complex culture. Their habits, clothing, hair, and language set them apart from the other miners, who themselves came from different countries and spoke various languages. The Chinese were labeled "outsiders" and often treated with prejudice and even violence. (Courtesy of the California State Library, Sacramento, California.)

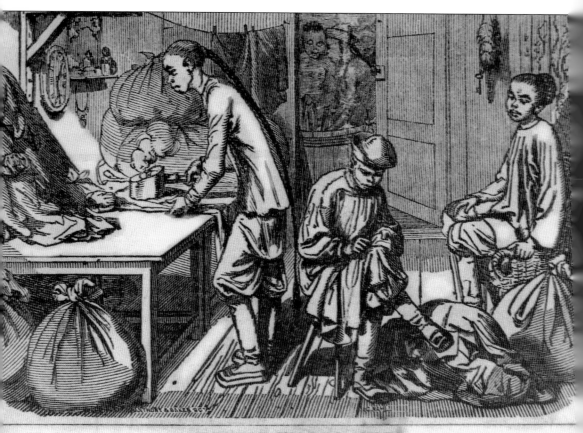

CHINESE WASH-HOUSES.

Because of the Foreign Miners' Tax, many Chinese abandoned mining for other pursuits. The Chinese laundry was ubiquitous in towns throughout California. Other Chinese entered domestic service. Chinese workers also provided labor for Coloma wineries. (Courtesy of the California State Library, Sacramento, California.)

Four

DAYS OF WINE AND ROSES

Following the Gold Rush, a new kind of gold emerged: agriculture. Vineyards and orchards proliferated throughout Coloma and Lotus beginning in the 1850s. Residents prided themselves on their gardens. Some old heritage roses from these early years still grow. In the 1860s and 1870s, growers hauled Coloma produce via wagon or train to silver mines in Virginia City. By 1920, 15 commercial orchards, producing peaches, pears, and apples, thrived. The produce garnered accolades at both the El Dorado County and California State Fairs and after the turn of the century was shipped to the East Coast. (Courtesy of MGDSHP.)

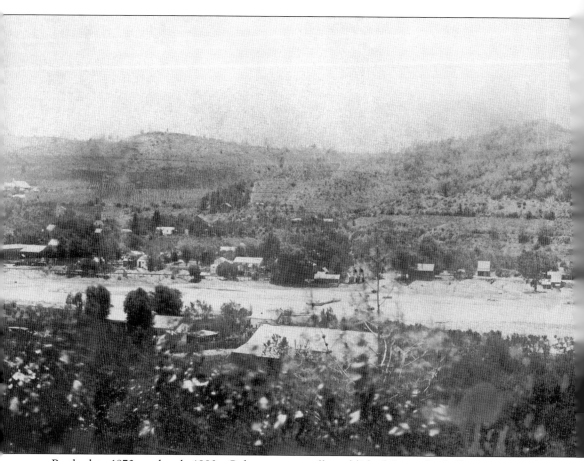

By the late 1870s and early 1880s, Coloma was a well-established Sierra foothill community. At the left on the far side of the river, the Sierra Nevada Hotel figures prominently, with part of the building jutting toward the river. The Vineyard House and Winery and St. John's Church are barely visible toward the left in the distance. A flume carries water to town buildings. The Coloma-Lotus Ditch, still used today, bisects the hillside. By this time, floods had washed out the

bridge yet again, so that all that remained was a barge or perhaps part of a bridge. By the 1870s, much of the north side of the street had been excavated for gold. To the right of Bridge Street is a blacksmith shop owned by former slave Rufus Burgess. Farther to the right is Coloma's crowded Chinatown. (Courtesy of MGDSHP.)

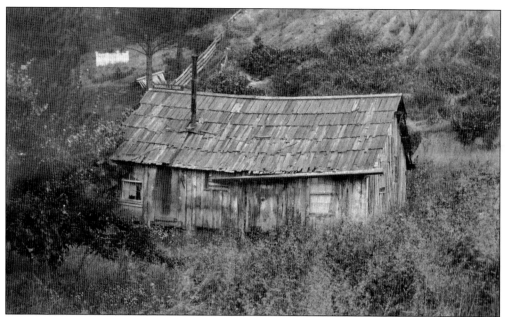

James Marshall constructed this cabin on approximately 15 acres, raising grapes and fruit trees that terraced the hillside behind his cabin. One of Coloma's first vintners, he raised exotic grape varieties from Europe. This cabin was the fourth he built in Coloma. The first two were built at other locations, while the third, built here around 1857, burned in 1862. Marshall promptly rebuilt the cabin, which still stands. (Courtesy of the California State Library, Sacramento, California.)

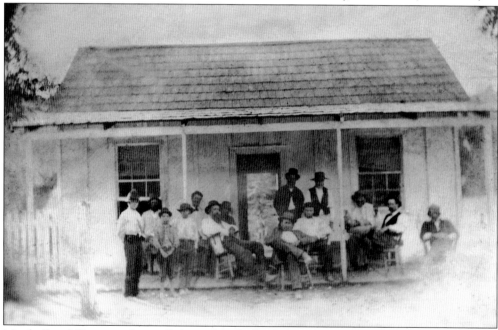

Marshall and 13 men gather in Coloma. Marshall is believed to be the man standing just to the right of the door. Mostly, Marshall enjoyed his years in Coloma and had many friends. Although he spent the rest of his life searching for the next big strike, he was unsuccessful. He lived in poverty in his final years. (Courtesy of MGDSHP.)

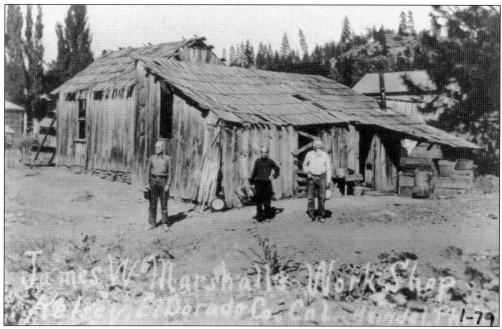

Marshall built this blacksmith shop in nearby Kelsey in 1872 and worked here until his death. Margaret Kelley, a Kelsey schoolteacher, reminisced in the *Mountain Democrat* newspaper in 1928: "The sound of his anvil was always heard at some period of the day, as he shaped a piece of iron, or sharpened tools for mining purposes." He lived at the nearby Union Hotel, dying there in 1885. (Courtesy of MGDSHP.)

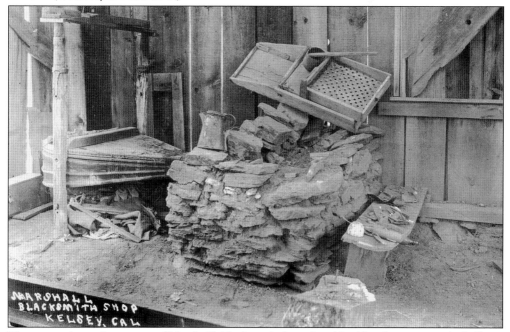

This image shows the interior of Marshall's blacksmith shop. An old gold rocker sits near the bellows. For the last years of his life, denied a state pension, Marshall supported himself with his blacksmithing and carpentry. Today, little remains of the blacksmith shop. (Courtesy of MGDSHP.)

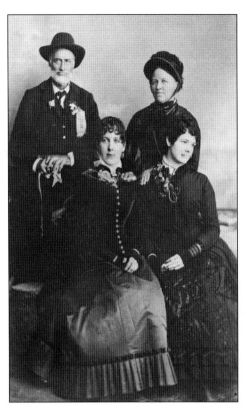

Margaret Kelley was responsible for preserving many of James Marshall's artifacts. Generally, Marshall shunned photographers. Shown here during a Sacramento outing are, from left to right, (first row) Polly Seisenop and schoolteacher Margaret Kelley, both from Kelsey; (second row) James Marshall and Mrs. Henry Treichler (a friend from Sacramento). (Courtesy of MGDSHP.)

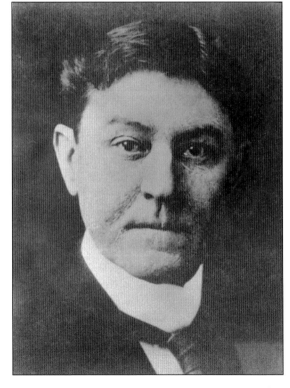

Early-day Coloma attorney Thomas Williams, California's first attorney general, built the fine Williams-Markham House on Sacramento Street. He later moved to San Francisco, where he became a wealthy landowner. In Coloma, he shared offices with D.K. Newell and John F. Long, justice of the peace. (Courtesy of the California State Library, Sacramento, California.)

The first Coloma schoolhouse was located adjacent to the courthouse on what is known as Piety Hill. This building dated back to about 1856. The school moved into the courthouse, shown here, after the county seat moved to Placerville. The building was leveled by a fire in 1919. (Courtesy of MGDSHP.)

The Williams-Markham House, built around 1856, was occupied in part by two noted early-day residents, Thomas Williams and Edwin Markham. Shown here, Markham taught school in Coloma in the 1870s. He lived in several other valley houses, all long gone. He wedded Annie Cox, from a local ranching family, in 1875 at Emmanuel Church in Coloma. They lived in the house briefly, but the marriage dissolved in 1884 after his affair with Elizabeth Senter, who died in 1885. Markham then married Caroline Bailey, but she moved out after Markham's overbearing mother joined the household. In 1898, Markham married his third wife, Anna Catherine Murphy, who adeptly guided Markham's later career. Markham moved to Placerville after his Coloma teaching stint and worked as a school administrator. Embracing socialism in later years, his political beliefs inspired his breakthrough poem, *Man with a Hoe*, which became an international sensation when it was published in 1899. Markham also wrote a well-known poem about Abraham Lincoln that he recited in 1922 at the dedication of the Lincoln Memorial. (Courtesy of MGDSHP.)

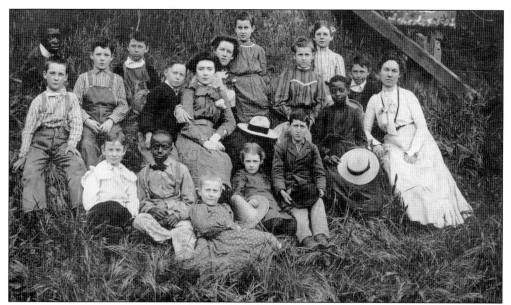

Coloma students pose on a grassy bank in 1902. Shown from left to right are (first row) Amos Smith, Marion Burgess, Cecilia Papini, Alma Mahler, and Joseph Hooper; (second row) Everett DeLory, Tom Kane, Albert Colwell, Agnes Kane, Maude Julian, George Colwell (behind and to the right of Maude Julian), and teacher Miss Tindall; (back row) James Monroe, Elmer Colwell, Annie Thomas, Margie Papini, Emma Papini, and Edwina Anderson. (Courtesy of Rita Archie, Philip Fancher, and Vickie Longo.)

Daisy Schulze, daughter of Charles Schulze, poses by the river behind her little house, later called the Howard House. Her father, Charles Schulze, built the house for her in 1916. Schulze owned the Sierra Nevada Hotel from the 1880s until 1922. Later, Daisy's house became a tack shop and still later a small sandwich shop. The State of California bought the house in 1959. Early on, the hand-dug well behind the house contained the best water in town. (Courtesy of MGDSHP.)

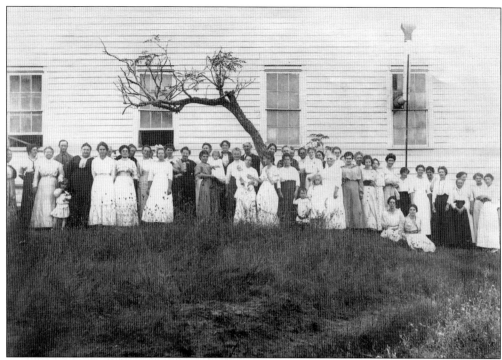

In 1915, the Coloma Women's Club gathered at the IOOF Hall in Coloma. In addition to the IOOF, other Coloma groups included the Druids, the Grange, and the Masons. This image shows women from some of the pioneer families, in no particular order: Gallaghers, Hoopers, Colwells, Thomases, Papinis, and Ulenkamps. (Courtesy of Rita Archie, Philip Fancher, and Vickie Longo.)

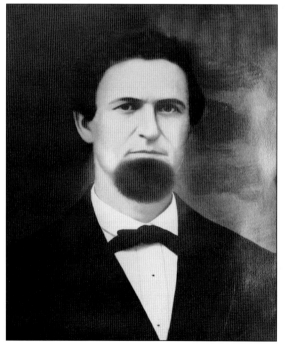

Martin Allhoff, born at Bretzenheim on the River Rhine on August 21, 1827, came to Coloma in 1849 with his brother John. He earned enough money mining gold to buy a home and about 35 acres of land. He then went to Ohio, where he married Louisa M. Weaver in 1852. They returned to Coloma, going into the wine business and eventually cultivating 160 acres of grapes. Highly successful, he expanded his market to Nevada, traveling by wagon. On one of these trips, in Virginia City on October 9, 1867, he committed suicide because of tax problems. (Courtesy of the California State Library, Sacramento, California.)

Louisa Weaver Allhoff Chalmers, a native of France, was 14 years old when she married Martin Allhoff. The widow with three children married Robert Chalmers in 1870. Louisa was Robert's third wife; the previous two had died young. Louisa and her husband lived for years in the spacious Vineyard House, which they built. They had two children, Robert, born in 1870, and Louisa, born in 1877. (Courtesy of MGDSHP.)

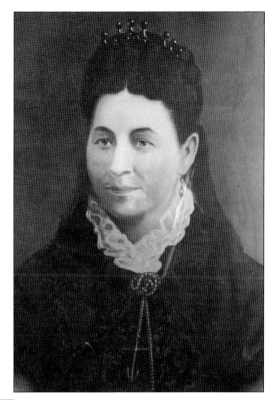

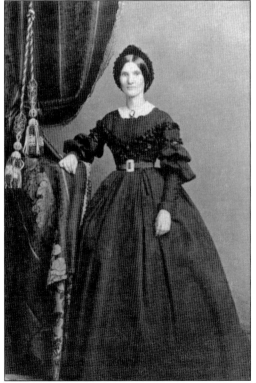

Originally from Scotland, Catherine Ferrier was the first wife of Robert Chalmers. She came to Coloma around 1850 with her sisters, Annie and Jessie. Annie married George Vincent, who published the *Empire County Argus* newspaper. Jessie married Luther Davis, owner of a bakery and confectionery shop. (Courtesy of Rita Archie, Philip Fancher, and Vickie Longo.)

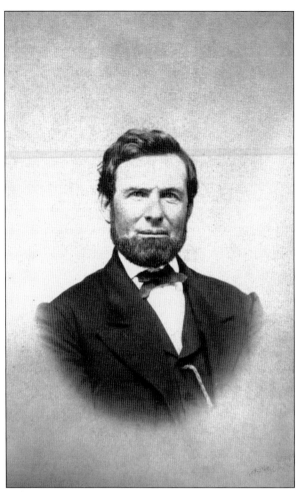

Robert Chalmers, longtime proprietor of the Sierra Nevada Hotel, builder and owner of the Vineyard House, and prominent California vintner, was born in 1820 in Scotland. Robert's parents moved to Canada when he was 14. At the age of 19, he married Catherine Ferrier, and they had six children. Coming to California about 1850, he mined and then worked for a baker, saving $2,500, which enabled him to buy the Sierra Nevada Hotel in 1852. A respected member of the community, Chalmers was voted county treasurer in 1867. (Courtesy of the California State Library, Sacramento, California.)

The wine cellars near the Vineyard House crumbled after the winery shut down. Martin Allhoff, an early-day winemaker, built the first two cellars in 1860 and 1866. After his death, Robert Chalmers took over the business and married Allhoff's widow, Louisa. He added a third cellar in 1875. When Chalmers died in 1881, legal problems plagued Louisa. Disease destroyed the vineyards, and the winery fell into ruins. (Courtesy of MGDSHP.)

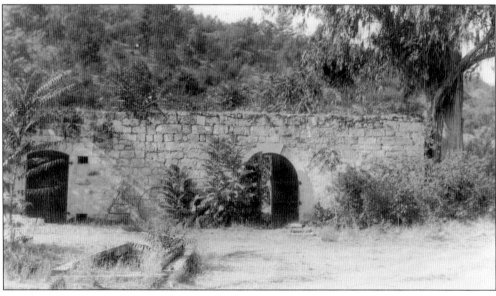

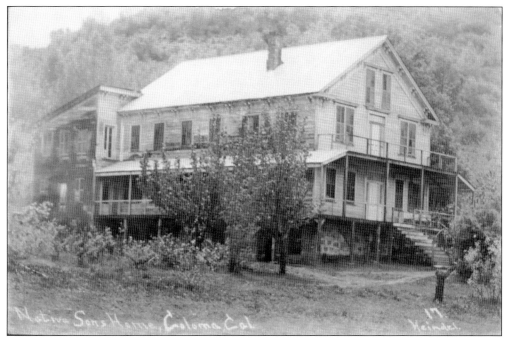

Built in 1878 by Robert Chalmers, the Vineyard House served as the family's residence and a hostelry for visiting wine merchants. The 18-room house, still the largest building in Coloma, cost $15,000 to build. Following the 1890 unveiling of Marshall Monument, attended by thousands of people, over 400 people ate dinner at the Vineyard House. California governor Robert Whitney Waterman sat at the head table. (Courtesy of the California State Library, Sacramento, California.)

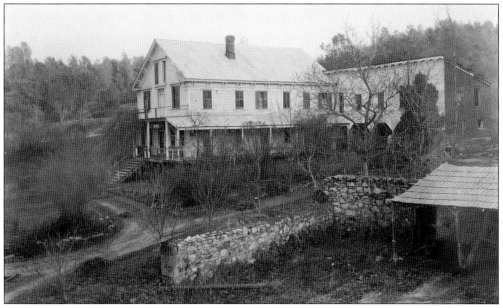

A ballroom measuring 25 by 90 feet at the south end of the building (visible here toward the rear) could accommodate great crowds. Pres. Ulysses S. Grant was one of many visitors who came here. Winery buildings were located to the right. The winery housed the Western Union telegraph office until 1884. (Courtesy of the California State Library, Sacramento, California.)

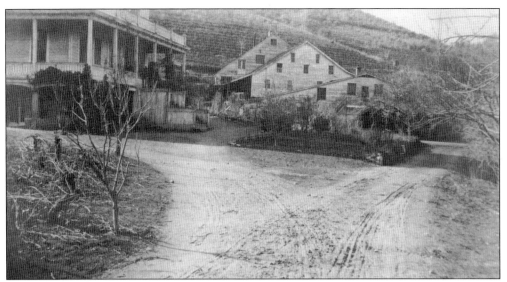

This winery was the largest in California outside of Napa Valley, according to Martin Allhoff Jr. Varieties included Angelico, Burgundy, Sherry, Port, Green Hungarian, Zinfandel Claret, Dry Muscat, Sweet Muscat, Catawba, Isbella, Tokay, Sauterne, Reisling, and Cocomingo. Cordials included blackberry, grape brandy, blackberry brandy, Chalmers, Catawba wine bitters, and orange bitters. (Courtesy of the California State Library, Sacramento, California.)

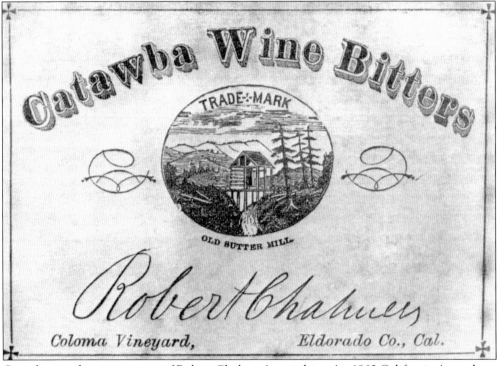

Catawba wine bitters were one of Robert Chalmers' specialties. An 1860 California Agriculture Report quoted Chalmers judging "Catawba the best of all grapes for wine purposes, as the vines are very hardy and the wine made from them meets a ready sale at a high price, it having a rich, fruity flavor." The bitters were celebrated throughout the West. (Courtesy of MGDSHP.)

Charles Nice was a winemaker at the Vineyard House. The winery was located on a hillside and consisted of three connecting buildings. Martin Allhoff Jr., whose father founded the winery, recalled in his memoir: "One particular feature about this winery was that during its existence not one employee had ever been discharged for drunkenness . . . during working hours." (Courtesy of MGDSHP.)

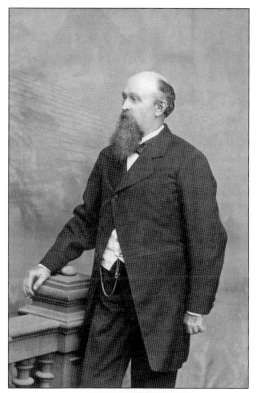

Schoolchildren from Coloma and Lotus gather with their parents at the Vineyard House in 1911. The grand building was the setting for many lavish celebrations. Hot chicken suppers and square dances were popular. Celebrations continued into the late 20th century, when the mansion was the setting for a popular restaurant, bar, and hotel. Today, it is a private residence. (Courtesy of Barbara Wagner Veerkamp.)

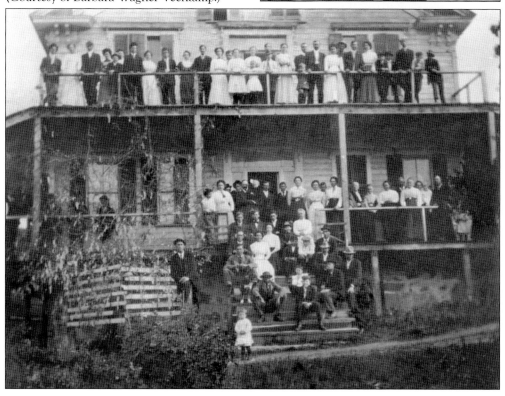

The William Pugh family cultivated Zinfandel and Muscatel grapes from the 1920s through the 1950s in Lotus, continuing the tradition started by James Marshall. The Coloma-Lotus Valley countryside was planted in wine grapes. Many vintages took top honors at the California State Fair. (Courtesy of Pearl de Haas.)

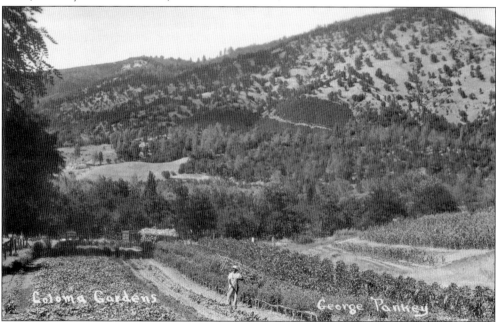

In the 1940s, George Pankey grew this expansive garden near the junction of Church and High Streets. The dry, warm summers make it easy to grow tomatoes, corn, peppers, squash, and other crops. In the late 19th century, miners' ditches traversing Mount Murphy made agriculture possible along the north side of the river. (Courtesy of MGDSHP.)

Five

SMALL-TOWN SLUMBERS

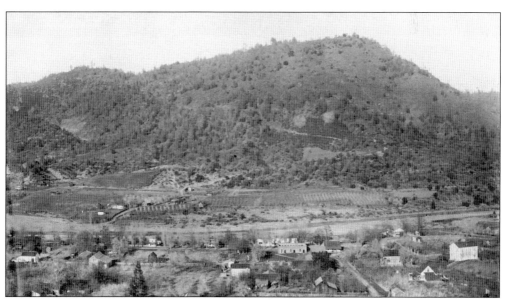

This pre-1877 view of Coloma shows Mount Murphy and some of the remaining buildings in the town, including the imposing walls of a brick store. Hotelier and winemaker Robert Chalmers used some of the store bricks to construct the Vineyard House. Later, Chinese laborers—hired by Chalmers— mined the street for gold. (Courtesy of the California State Library, Sacramento, California.)

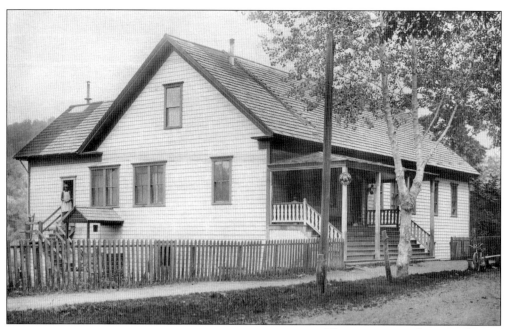

This structure is the second Sierra Nevada Hotel. After the first Sierra Nevada Hotel was destroyed by fire in 1902, it was rebuilt in 1903. The second building, owned by Charles Schulze and later by Andrew Marchini, burned in 1925. In the 1920s, Coloma residents enjoyed watching motion pictures here. The projector was powered by a generator. Commemorating the first two hotels, John Hassler built the Sierra Nevada House in 1960 at the corner of Lotus Road and State Highway 49. (Courtesy of MGDSHP.)

Martin J. Allhoff, son of vintner Martin Allhoff, served as a telegraph operator in Coloma. He was deemed a first-class Morse-code operator. The Coloma office had wire connections to Sacramento, Georgetown, and Auburn. Martin J. Allhoff was also the leader of the Coloma Brass Band, which played at the unveiling of Marshall Monument in 1890. He played the E flat cornet. (Courtesy of MGDSHP.)

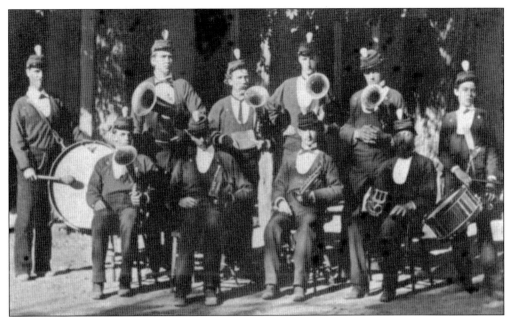

The Coloma Brass Band was a longtime fixture at Coloma celebrations. An 1882 edition of the *Lotus Press* praised, "Early in the evening the Coloma Brass Band began to send forth their sweet strains on the dismal night air to entertain those already assembled and await the arrival of those coming from a distance. Their music was greatly appreciated and well it should be for the boys did better than usual giving evidence of their steady and rapid improvement." (Courtesy of MGDSHP.)

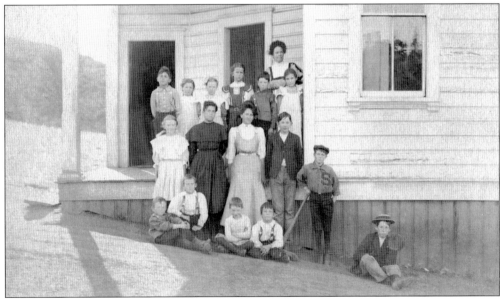

This early-20th-century image depicts schoolchildren at Slatington School, near Kelsey at the old slate mines. Built in 1903, the school closed in 1911 because of low enrollment. When the first Coloma schoolhouse burned in 1919, townspeople staged a grand ball to raise funds to buy the abandoned Slatington School building. They purchased the building for $200, dismantled it, and rebuilt it in Coloma in 1920. (Courtesy of MGDSHP.)

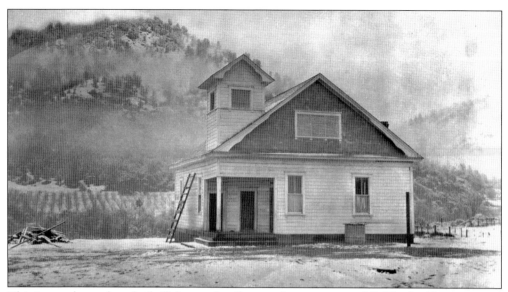

This image shows the rebuilt Coloma schoolhouse after a rare snowfall. The building was used as a schoolhouse until June 1958. After the first schoolhouse burned in 1919, students attended school for a year on the first floor of the IOOF Hall. In 1956, the Gold Trail Union School District consolidated seven one-room schools into a new building on Cold Springs Road in Gold Hill. By the fall of 1958, students were bused to the new school. Today, the Coloma schoolhouse has been restored to its early-day charm; thousands of schoolchildren visit each year. (Courtesy of MGDSHP.)

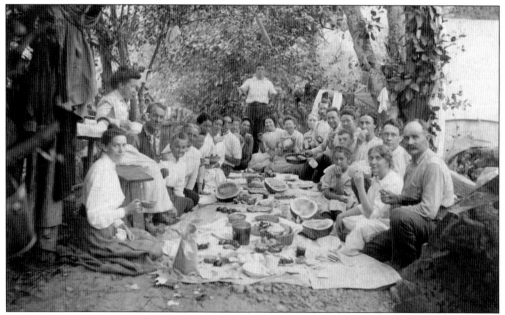

Picnickers celebrate a Coloma summer day. Recalled Coloma veteran Mrs. G.H. Metcalfe of the small-town life in the 1920s, "Well, Coloma was a nice, peaceful town when we came here. There was no one or nothing to be afraid of. Everyone was friendly. If anybody killed a deer they gave you some meat, and if you killed one, you gave some meat. It was a nice place to live." (Courtesy of MGDSHP.)

Coloma native Fred Thomas, a fruit grower and gold miner, poses with a fine horse next to the river. Born in Coloma in 1879, Thomas was one of five children born to Olive and Joseph Thomas: Frank, LeRoy, Mamie (Thomas), and Annie (Jaeger). In 1906, Fred married Cora Price, daughter of John Price, who had owned a lovely home (now restored) in Coloma since the 1870s. The Thomas family lived for many years in what is now called the Thomas-Noteware House. (Courtesy of MGDSHP.)

Verna (Winje) Dodds was one of eight children born to Sam (Sverre) Winje, a Norwegian, and Cora (Marchini) Winje. The family has been part of the Gold Hill–Coloma community for generations. Many Italian-Swiss and Italian families settled locally. (Courtesy of Kurt de Haas.)

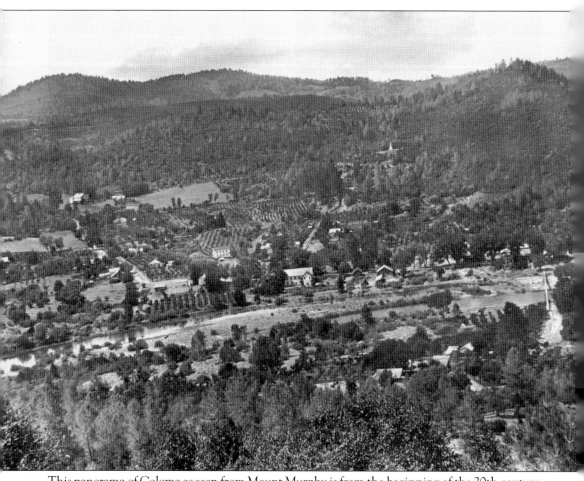

This panorama of Coloma as seen from Mount Murphy is from the beginning of the 20th century. The photograph shows extensive orchards and dredger tailings. Houses crowd the north side of the river, spanned by a footbridge. The Sierra Nevada Hotel, IOOF Hall, Vineyard House, and

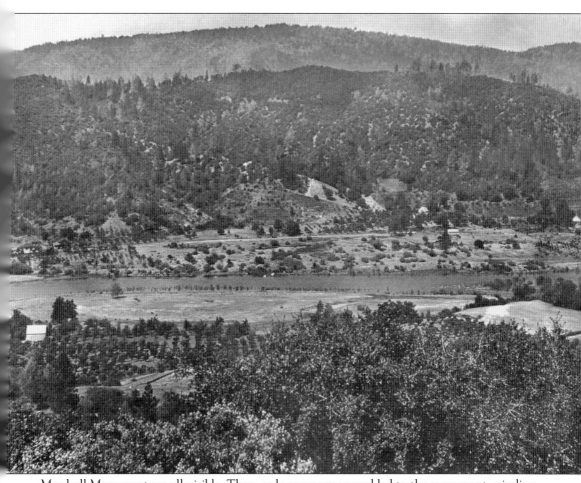

Marshall Monument are all visible. Then, only one narrow road led to the monument, winding up the hill past St. John's Catholic Church and Marshall's cabin. (Courtesy of MGDSHP.)

To the left of the wandering cow is the Kane House, built on Main Street in 1886 by Tom Kane, an early-day orchardist. The house briefly served as the post office. His son Henry Kane was caretaker at the Catholic cemetery behind the Catholic church. Henry once discovered a man trying to steal honey from bees that had settled into the church's wall. Henry claimed the thief threw a hatchet at him. During the trial—held in the dance hall of the Sierra Nevada Hotel—Henry treated the entire jury to drinks. They ruled in his favor. In the 1990s, the historic house became the home of the American River Conservancy. (Courtesy of the California State Library, Sacramento, California.)

Shown here at age 85, Dorcas Papini was born in Coloma in 1877. Her father, William Hooper, was an orchardist and rancher who came to Coloma in 1850. She married Joseph Papini in 1891; they had four daughters and a son. All of the girls became schoolteachers. The family's tiny home, which has been restored to its early-day appearance, stands on the site of a bakery and confectionery owned by Luther Davis, who came to Coloma in September 1849. The Papini and Fancher families deserve much credit for keeping Coloma history alive. (Courtesy of Rita Archie, Philip Fancher, and Vickie Longo.)

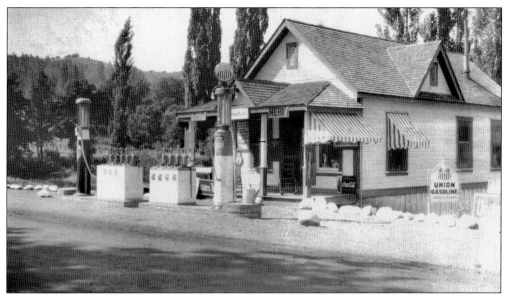

The George Pontius store was located in a building east of the Weller House. Over time, a bar, café, gas station, and small store called the Hitching Rack operated from the building. It was torn down in 1967. Owner Jim Bridgman added stonework and the area known as the Beer Garden, which picnickers still use. During the Gold Rush, the Metropolitan saloon and gambling house flourished here. (Courtesy of Rita Archie, Philip Fancher, and Vickie Longo.)

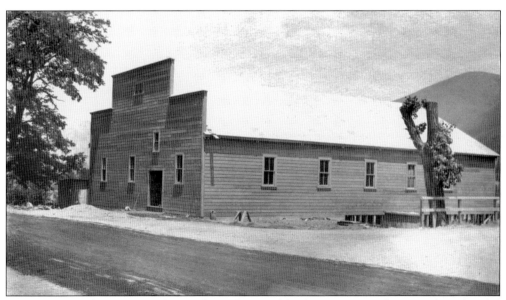

After the second Sierra Nevada Hotel was destroyed by fire in 1925, Coloma residents banded together to build this large community hall, completed in 1926. Over the years, it has been the setting for numerous dances, potlucks, Scout meetings, and celebrations. (Courtesy of Rita Archie, Phillip Fancher, and Vickie Longo.)

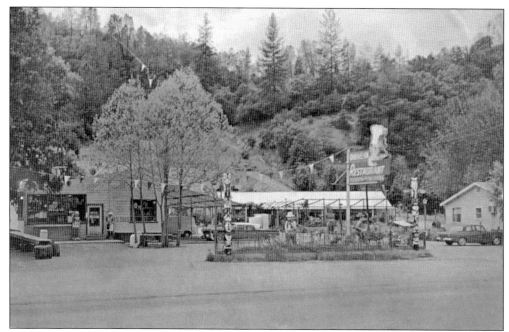

"Coloma Lil" (Lillian Abatti) and her husband, Joe, were colorful residents of the valley in the 1950s and 1960s. They ran a diner near what is now preserved as the historic Monroe Orchard, across from the North Beach picnic area. This postcard depicts the sometimes kitschy business. (Courtesy of John Tillman.)

Fried Chicken ⋯ 1.50
French Fried Jumbo PRAWNS ⋯ 1.50
Ground Chuck Steak *Smothered Onion* 1.50
Breaded VEAL ⋯ 1.40
Hamburger Steak ⋯ 1.35
FISH N FRIES ⋯
Top Sirloin STEAK *(With Dessert)* 1.75
Hot Beef Sandwich ⋯ 90
BAR-B-Q BEEF ⋯ 60
JUMBO Burger ⋯ 70
JUMBO Cheese Burger ⋯
FOOT LONG Hot Dog ⋯ 50
STEAK Sandwich ⋯ 1.00
RIB STEAK *Complete Dinner* 2.75

French Fries
"Coloma LIL'S" Horse ⋯ 15
Home Made PIE *Per Cut*
MILK SHAKES ⋯
MALT
Ice Cream SODA ⋯ 45
SUNDAES
Banana SPLITS
Large SODA Drinks ⋯ 20
Small SODA Drinks ⋯ 15
TEX MIX *(NO LIMIT)*
FROSTIE Hot Chocollor ⋯ 35
FROSTIES ⋯
also SPECIALS of the WEEK

Coloma Lil's menu wouldn't appeal to dainty eaters. Hamburgers, steaks, fries, and ice cream predominated. Living on the flood plain did not add to quality of life. The park bought out Lil and Joe, and they sought higher ground. Today, only foundations remain. For a time, a garage was located across the street, but that too is long gone. (Courtesy of John Tillman.)

Six

A PROUD AFRICAN AMERICAN LEGACY

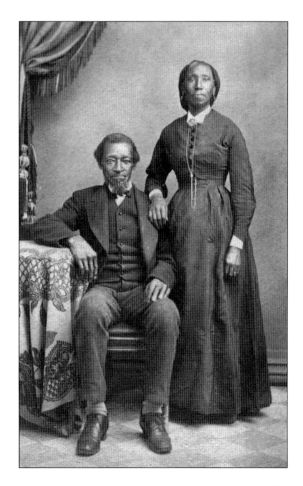

This is believed to be the 1857 wedding photograph of Nancy and Peter Gooch. Both came to California in 1849 as slaves but were freed when California became a state in 1850. Nancy Gooch was born Nancy Ross in Maryland in 1811, a free person of color. Likely abducted by slave catchers, she was sold to William D. Gooch of Virginia. During the Gold Rush, William sold Nancy's three-year-old son, Andrew, to a Missouri slave owner named Monroe to pay for passage to California. Taking Nancy and Peter with him, he reached California by wagon train. William owned the Crescent City Hotel for a time and died prior to 1854. Peter Gooch died in 1861. (Courtesy of MGDSHP.)

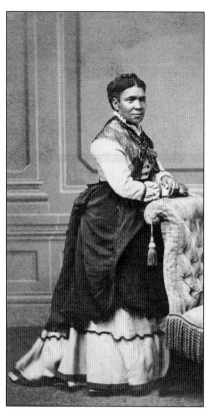

Andrew Monroe, Sarah Ellen (his wife, shown here), and their two sons arrived in Coloma from Missouri. When Andrew was three, he had been separated from his mother, Nancy, when William D. Gooch sold him in Missouri to pay for passage to California and took Nancy and Peter with him. When California became a state in 1850, Nancy and Peter were freed. Many years later, Nancy had saved $700 from her earnings at menial labor and finally paid for the passage of Andrew and his family to Coloma. They arrived from Missouri between 1869 and 1870. Andrew died in 1921, and Sarah passed away in 1937, leaving behind seven children. (Courtesy of MGDSHP.)

Although Andrew and Sarah Monroe were both born into slavery, by 1885, they prospered as merchants. They sold fruit and vegetables to places as far away as Virginia City. Over the years, the Monroes bought a total of 80 acres of property in and around Coloma, including 10 lots on Main Street. Pearley, Nancy's grandson, acquired the original site of Sutter's Sawmill in the 1890s. None of Nancy's grandchildren had children. Shown here in front of their Coloma house, from left to right, are Delia, Andrew, Jim, Sarah, Andrew Sr., Garfield, Pearley, William, and Grant (on wagon). (Courtesy of MGDSHP.)

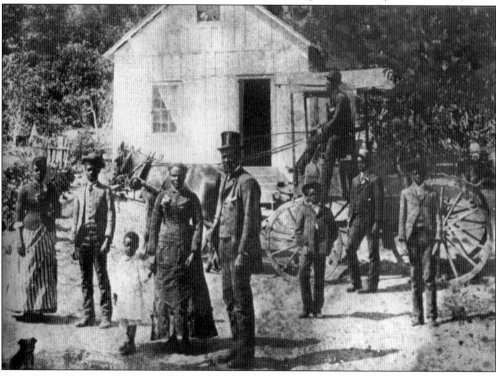

The close-knit Monroe family is shown here in the mid-1880s. From left to right are (first row) Cordelia (Delia), James, Andrew Sr., Garfield (kneeling) and Sarah Monroe; (second row) William, Grant, Pearley, and Andrew Jr. Pearley (Almariah) was perhaps the best-known of the children, becoming a major landowner and successful Coloma businessman despite having only three years of formal education. He built a blacksmith shop and an adjacent building, as well as a larger warehouse behind the blacksmith shop. In the early 1970s, Charlie, Bill, and Dave Butterfield began blacksmithing demonstrations here, and the tradition has been carried on ever since. Pearley died in 1963 at the age of 94. (Courtesy of MGDSHP.)

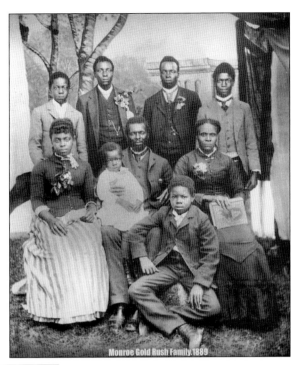

Monroe Gold Rush Family.1889

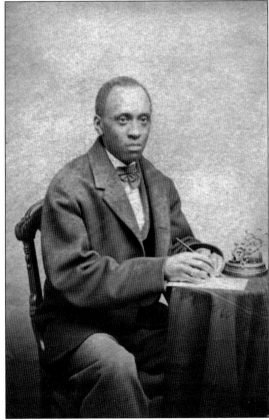

Rufus A. Burgess was a slave who came to California with his owner during the Gold Rush. At one time, five black families lived in Coloma, including the Julians, Wilsons, Monroes, and Burgesses. The Burgesses lived in the area where the state park maintenance yard is now located. (Courtesy of MGDSHP.)

81

Shown here in his World War I uniform is Marion Burgess. He was one of three sons born to Rufus and Stephanie Burgess. Their other sons were Rufus Jr. and Edgar (known as Tod). Marion recalled life in the old days: "Coloma was a quiet town. Everybody was good . . . People would come and visit one another. Everybody had a jug of wine. They'd take a glass and sit and talk . . . They told some pretty big whoppers." (Courtesy of MGDSHP.)

Shown here, Arnold Underhalen (left) and Edgar Burgess pose in boxing gear during a friendly match. Coloma's hard-working black families were assimilated easily into the community. Along with the Monroes, the Burgesses grew fruit on both the flatlands and terraced hillsides close by. Terraces still shape the hillsides. (Courtesy of MGDSHP.)

Seven

HONORING THE GOLD RUSH

Following James Marshall's death, family inheritance issues clouded title to land surrounding Marshall's cabin. The Native Sons of the Golden West finally raised enough money to clear the title, and work on the monument began in 1888. The 41-foot monument marks Marshall's burial place. (Courtesy of MGDSHP.)

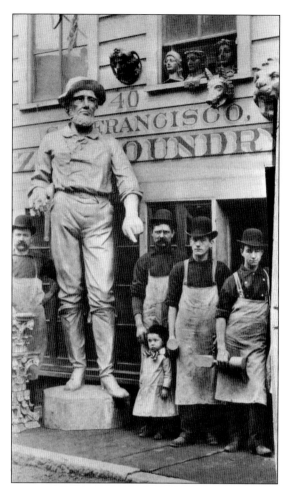

The Kremer Brothers Foundry in San Francisco poured this 10-foot statue of James Marshall. It was made of white metal (a tin, lead, and zinc alloy) and coated with a bronze wash. Former Parisian Jacques Kremer is on the left. On the right are other Kremer family members and workmen. Berkeley sculptor F. Marion Wells designed the statue. (Courtesy of MGDSHP.)

The Marshall Monument dedication in May 1890 attracted thousands. Coloma resident Dorcas Papini, then a small child, recalled, "I must confess that I cried the day Marshall was buried. Of course, I had a kind regard for Marshall, but the day they buried him I was wearing a pair of shoes that hurt my feet as I climbed the hill to his last resting place. They hurt so badly I cried." (Courtesy of MGDSHP.)

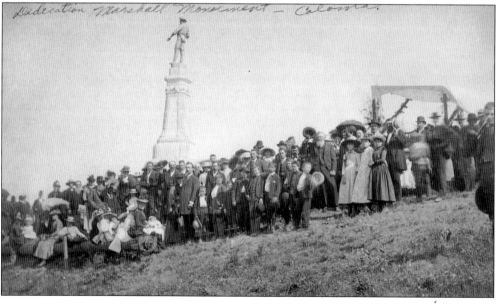

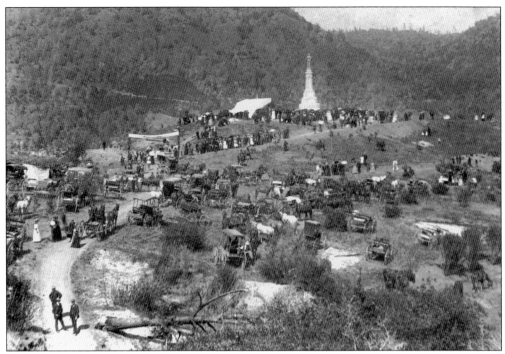

This view of the newly unveiled monument is taken from the Monroe Ridge Trail area facing northeast toward Mount Murphy. The $9,000 construction costs were paid from a $5,000 appropriation from the California State Legislature in 1887 and a second appropriation from the legislature soon afterward, as the $5,000 only covered the sculpture costs. Construction took place in 1888 and 1889. (Courtesy of MGDSHP.)

A crowd celebrates the dedication of Marshall Monument. Andrew Monroe is in the front row on the right. Louis Steffani, of nearby Garden Valley, waves the Swiss flag in honor of John Sutter. Until 1938, access to the monument was by means of a curving, one-lane road. Funds for a new road were authorized that year, and in 1940, the Works Progress Administration completed work on the new Highway 153—the shortest state highway in California. (Courtesy of MGDSHP.)

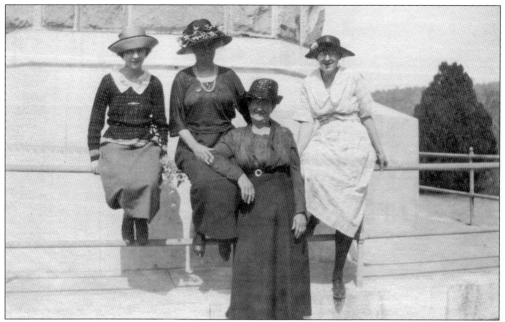

After the 1890 dedication of Marshall Monument, the Native Sons of the Golden West deeded the site to the state, and it has been a popular destination ever since, as evidenced by the lovely local Metcalfe women and friends posing in the early 1900s. The 25-acre monument site was a separate park until 1957, when the monument was officially linked to the gold discovery site. The State of California had purchased the parkland in 1942 from Pearley Monroe. Over the years, additional land and structures were acquired. Today, the park is over 575 acres and encompasses about two-thirds of the town of Coloma. (Courtesy of Clarence and Betty Nichols.)

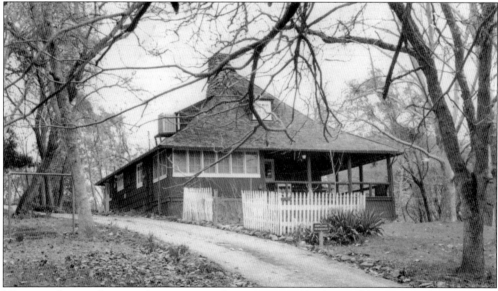

The caretaker residence at the monument began as a small cabin and later was enlarged. It was completed in 1918. For a while, caretakers used the front room as a museum. Visitors have used the picnic area here since about 1890. The monument site was California's second state park, after Yosemite, which later became a national park. (Courtesy of MGDSHP.)

In 1891, Ezra "Cow" Smith was appointed as California's first historical park ranger. Here he poses with a woman who is believed to be his wife, although some historians speculate that this may have been his daughter. He was first custodian at the monument. A resident of Coloma since the 1850s, he gained his nickname because he kept the first commercial dairy cows in Coloma. He was a fine dancer, and he planted many flowers and shrubs at the monument. Back in 1854, he had restored and refitted the Nichols' Hotel, one of the 10 hotels in Coloma in the 1850s, and advertised it as "a comfortable home for every miner." (Courtesy of MGDSHP.)

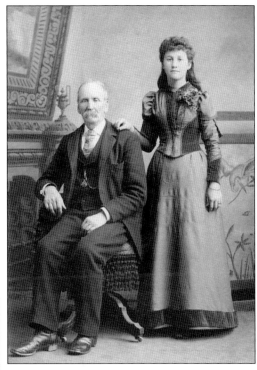

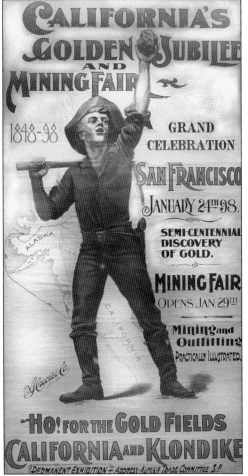

By 1898, California was more mindful of its Gold Rush history. In San Francisco, an enthusiastic crowd of 200,000 celebrated the 50th anniversary of the discovery of gold, sponsored by the Society of California Pioneers. The *New York Times* rhapsodized, "in San Francisco, where the festivities are to be kept up from the 24th to the 29th of the month, there are to be processions, orations, banquets, excursions, and all sorts of outdoor and indoor exercises, to manifest the joy and pride of the people." (Courtesy of the California State Library, Sacramento, California.)

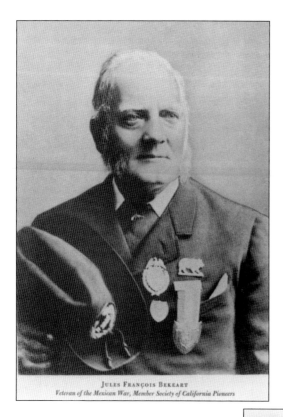

JULES FRANÇOIS BEKEART
Veteran of the Mexican War, Member Society of California Pioneers

Jules François (Frank) Bekeart is photographed here wearing an array of medals. A veteran of the Mexican War and a history enthusiast, Bekeart retired from the firearms business in 1890. He passed to his descendants a large legacy of documents and artifacts relating to California history. (Courtesy of MGDSHP.)

Thanks to the Bekeart family collection, Coloma historians have access to valuable stores of photographs and ephemera, some of which are now archived with the Marshall Gold Discovery State Historic Park and the California State Library. Philip Bekeart is seated at a table that is now housed in the research library in the state park. (Courtesy of MGDSHP.)

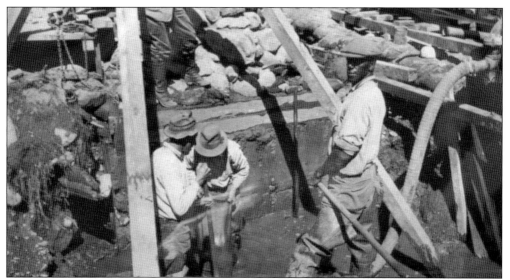

Neglect and frequent flooding obscured the exact location of Sutter's Mill for many years. However, in 1924, when river water was low, C.F. Clark of Coloma discovered the foundation timbers on land owned by Pearley Monroe. Clark sent a sample of the wood to Philip B. Bekeart in San Francisco. Bekeart rushed to Coloma and quickly hired a team to excavate the site. (Courtesy of MGDSHP.)

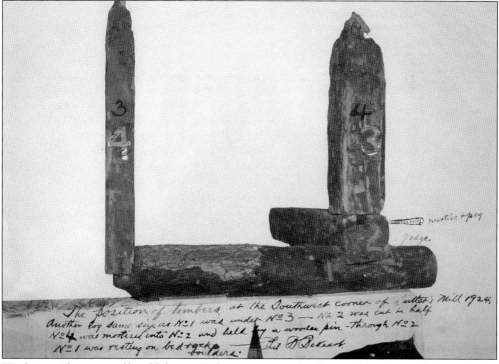

Working with a team of local laborers, Bekeart set up a wing dam and a pump and dug eight feet to bedrock, discovering a saw blade, mill irons, and wood that had been part of the west end of Sutter's Mill. This image shows the notes Bekeart carefully added to the image of the wood foundation. (Courtesy of MGDSHP.)

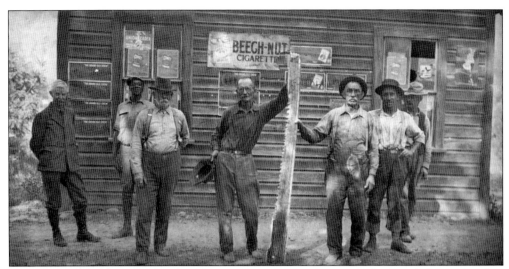

Local Coloma residents display the whipsaw discovered at Sutter's Mill. From left to right, they are county surveyor Henry Laheff (Lahiff), Marion Burgess, Henry Gallagher, Joe McGonagle, Henry Kane, Philip Bekeart, and George Johnson. (Courtesy of MGDSHP.)

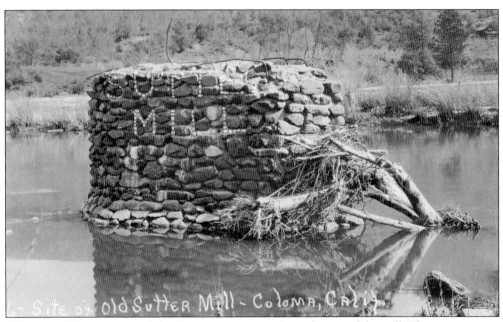

Bekeart and his crew erected this large stone monument at the site of the mill. The monument is 18 feet high, 22 feet long, and 9 feet wide at the base. The monument was repaired and stabilized in 1945 in preparation for the centennial celebration of the Gold Rush. Shown here is damage caused by a flood. (Courtesy of MGDSHP.)

Cary M. Traylor, the first ranger in the park, was appointed on February 6, 1942, and retired in July 1956. Although Ezra "Cow" Smith was the first park custodian in 1891, he was not a uniformed ranger. Traylor presided over the major development of the park, the acquisition of the gold discovery site, and the grand centennial celebration and parade in 1948. He is pictured here at his previous appointment at Calaveras Big Trees State Park. Traylor was the first California state park ranger to draw a gun in the line of duty, an event that occurred when he apprehended a fleeing burglar near Calaveras. Traylor's daughter, Florence, married rancher Merlin "Buzz" Winje. Family members still live in the area. Buzz was an important part of Coloma society. (Courtesy of Kurt de Haas.)

Perhaps the grandest event to happen in Coloma since the Gold Rush was the 1948 centennial celebration commemorating the discovery of gold. An estimated 30,000 people came to the quiet little town. This aerial view faces north, showing two large circus tents and a carnival midway. (Courtesy of MGDSHP.)

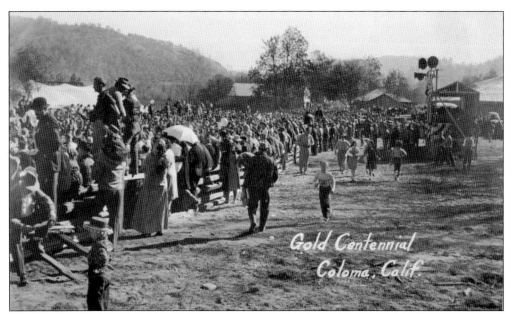

At the 1948 centennial celebration, people rushed about to view various dignitaries and movie stars. California governor Earl Warren (later chief justice of the Supreme Court) gave a speech, as did Joseph R. Knowland, chair of the state centennial commission. Knowland was a congressman and owner of an important newspaper, the *Oakland Tribune*. (Courtesy of MGDSHP.)

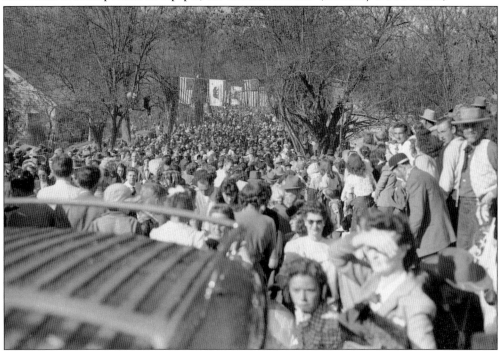

During the celebration, cars jammed roadways for miles. Old-timers report that cars were parked as far as two miles away, past the town of Lotus. Pedestrians and cars crowded the flag-draped streets of Coloma. This view was taken from the Coloma Schoolhouse, facing north. (Courtesy of Barbara Wagner Veerkamp.)

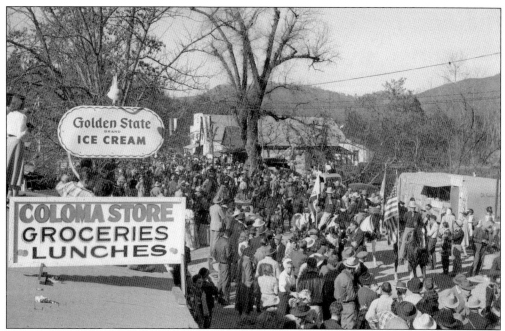

Visitors enjoyed the day at the centennial celebration in Coloma. The day featured speeches, a parade, a midway, and a play written especially for the event. At the center of this melee were parade marshals Roy Rogers and Dale Evans, the popular stars of television and film. (Courtesy of the California State Library, Sacramento, California.)

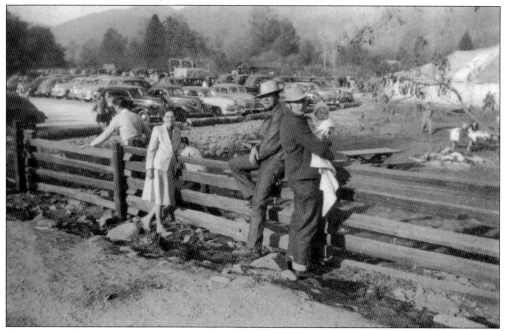

Clarence and Betty Nichols enjoyed the centennial celebration with their young children. Although the Nichols family lived only a mile away from Coloma, visitors flocked to the town from all over California. Betty's family, the Grothers, ranched in the Lotus and Long Garden areas for generations. (Courtesy of Clarence and Betty Nichols.)

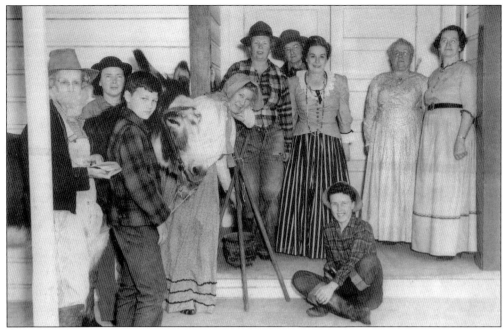

Photographed at the Coloma Community Hall in period attire are (from left to right) Annie (Thomas) Jaeger, Mary Wagner, Robert Seril (by donkey), Violet Reaside, Narcissa Veerkamp, Dorothy Metcalf, Gladys Veerkamp, Mai Veerkamp, and Annie Bassi. Marcella Herzig is seated on the floor. (Courtesy of Barbara Wagner Veerkamp.)

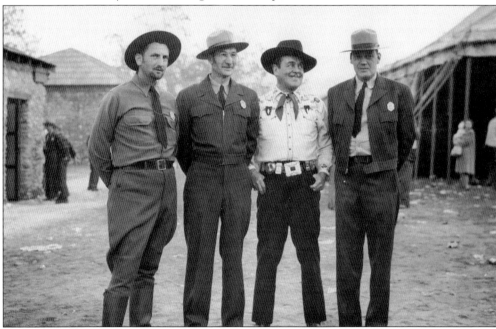

Leo Carrillo, who starred in more than 90 films, often playing Latino roles, joined in the Gold Rush centennial. The university graduate came from an old, respected California family. Standing by the Chinese stores and circus tent, from left to right, are park ranger Roland Geyer, park ranger Glen Jackson, Carrillo, and deputy ranger Stan Jones. (Courtesy of MGDSHP.)

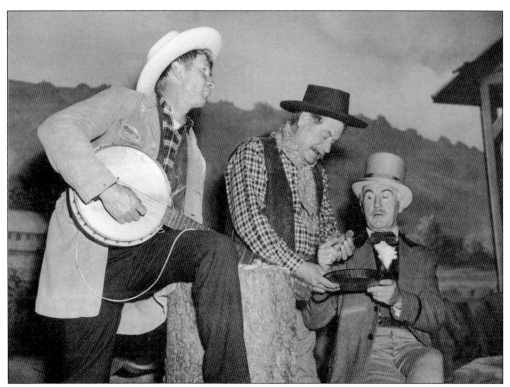

A banjo player plucks accompaniment while Leo Carrillo (center) hams it up in a play re-enacting the discovery of gold during the centennial celebration. Carrillo was also a conservationist and served on the California State Park Commission for 18 years. Singer and movie actor Chill Wills also participated in the play. (Courtesy of MGDSHP.)

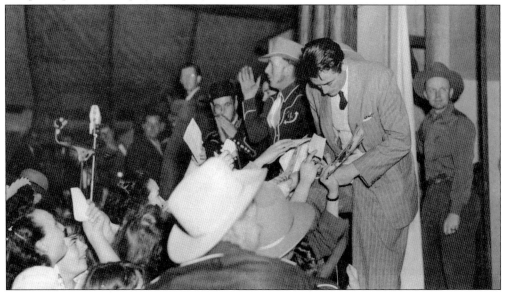

In the Coloma Community Hall, enthusiastic fans crowd around Hollywood actor Gregory Peck, who narrated the play at the centennial celebration. Over his career, Peck was nominated for five Academy Awards. (Courtesy of MGDSHP.)

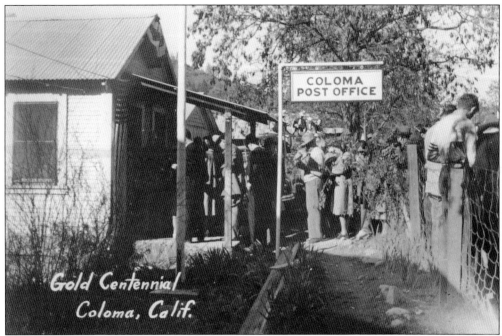

Stamp collectors lined up to buy first-day covers at Coloma's tiny post office. Bankrupt and living in poverty late in life, James W. Marshall, credited with discovering California's gold, acquired posthumous fame, beginning with the dedication of his ornate burial monument. By the time of the centennial celebration, the carpenter and blacksmith had become a celebrated figure in the history of the American West. (Courtesy of MGDSHP.)

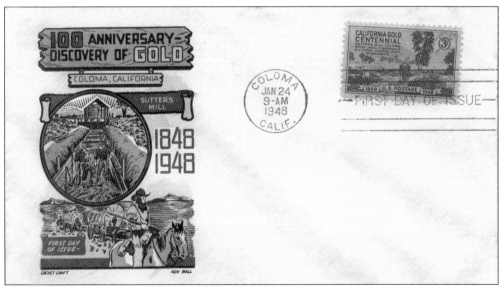

This first-day cover, one of several issued on January 24, 1948, commemorated the discovery of gold. In addition to the 3¢ stamp depicting Sutter's Mill, the envelope also featured sketches showcasing various episodes in California history. (Courtesy of Jeff and Barbara Lee.)

In 1958, Coloma again celebrated the discovery of gold. Here, the Air Force Band marches down Main Street. The celebration came about through the efforts of Virginia Rimple, who with her husband, Frank, owned the Vineyard House and turned it into a popular restaurant, bar, and hotel after a long hiatus. She was the first president of the Coloma Lotus Boosters Club. Early members included John Dixon, Harold Sederquist, Manfred de Haas, and Jack Edwards. In 1972, Gov. Ronald Reagan served as parade marshal. The park canceled the annual event in 1975 because of security concerns. Today, events honoring the discovery of gold are much quieter. (Courtesy of Kurt de Haas.)

The Mormon cabin located next to the sawmill replica was originally built on a mining claim, shown here, about 10 miles east of Georgetown in the Eldorado National Forest. The old cabin was dismantled and rebuilt in Coloma in 1971 by the Sierra Chapter of the Sons of Utah Pioneers. On January 23, 1972, it was dedicated at an event that attracted thousands of attendees. (Courtesy of MGDSHP.)

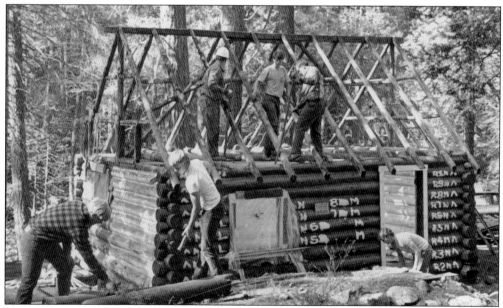

In 1960, volunteers began dismantling the Mormon cabin in preparation for its move. The Mormons, also known as Latter-day Saints, were prominent in California's history before and during the Gold Rush. James Wilson Marshall used at least five Mormon workers—former members of the remarkable Mormon Battalion—to construct Sutter's Mill. (Courtesy of MGDSHP.)

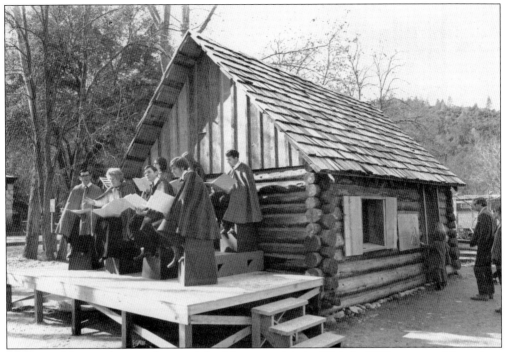

A choir celebrates the completion of the Mormon cabin in 1972. In 1849, a stout cabin such as this one would have been one of the more comfortable accommodations to be found in the town. The first cabin in the valley was built in 1847 for James Marshall's workers. That cabin no longer exists. (Courtesy of MGDSHP.)

The state park museum, dedicated on January 22, 1961, showcases much of Coloma's history. Built at a cost of $200,000, it now also houses a research library and a gift shop. California governor Edmund G. Brown, state parks director Charles DeTurk, and Joseph Knowland were among the dignitaries scheduled to speak at the museum dedication. The plaque in front of the museum designates Coloma as a National Historic Landmark. (Courtesy of MGDSHP.)

Completed in 1967, the replica of Sutter's Mill was dedicated in 1968 with thousands of visitors in attendance. Planning started in 1963, but actual work started about 1965. Placerville Lumber Company owners Harvey West and his son, Bob, donated lumber for the replica. The large timber was cut at mills near Eureka in northern California. (Courtesy of MGDSHP.)

A crowd gathers for the dedication of the replica of Sutter's Mill. It could not be built on the original site on the river because of the flood risk; indeed, floodwater destroyed the original mill only a few years after it was constructed. Even the replica has been flooded several times over the years. (Courtesy of MGDSHP.)

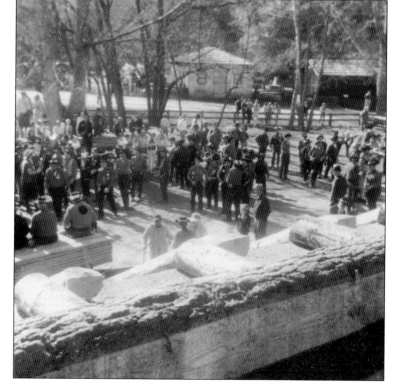

Eight

LOTUS, GOLD HILL, AND BEYOND

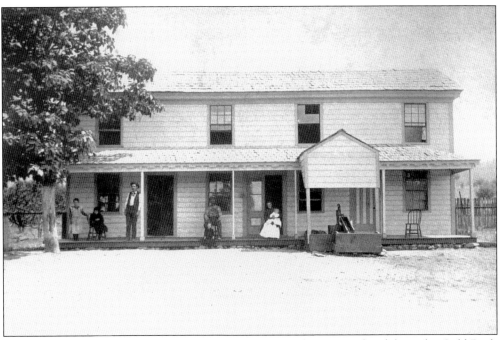

Photographed in 1892, the prosperous Temperance Hotel in Lotus dated from the Gold Rush days. It was torn down in the 1990s. From left to right are Edna Turnbeaugh, Hattie Turnbeaugh, Albert Roberts, Martha Turnbeaugh (seated in front of her father), James Turnbeaugh, and Mrs. James Turnbeaugh (holding daughter Irma). Recalled Irma many years later, "I don't know why they called it the 'Temperance.' I saw more whiskey poured there than you can imagine." Although Coloma, Lotus, and Gold Hill are separate communities, residents have maintained close ties and socialized with one another since the Gold Rush days. (Courtesy of Wayne Ragan and family.)

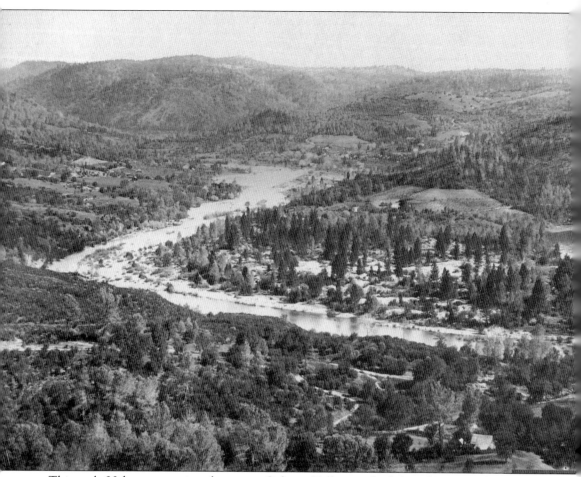

This early-20th-century view showcases Coloma Valley on the left and Lotus Valley on the right. The towns of Coloma and Lotus are visible in the far distance. Dredger tailings crisscross the massive river bend, and the Lawyer House gleams white at the lower right adjacent to a

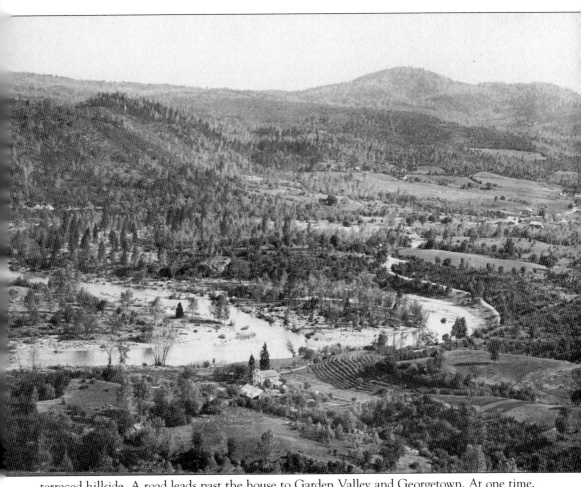

terraced hillside. A road leads past the house to Garden Valley and Georgetown. At one time, the 18,000-square-foot Tell House near the top of the grade served travelers. The Tell House foundation is still visible on the Bacchi Ranch. (Courtesy of Allan Veerkamp.)

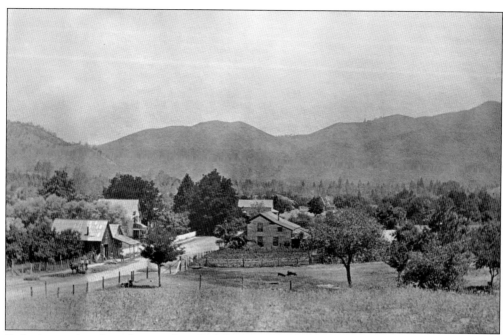

Early-day resident Irma Lawyer described the Lotus of her childhood: "It had two saloons, two grocery stores, a blacksmith shop, several residences on Main Street, and of course the school down the road." In contrast to the sometimes unruly town of Coloma, Lotus was considered more suitable for families. During the Gold Rush, perhaps 1,000 men labored on nearby Granite and Shingle Creeks. (Courtesy of Clarence and Betty Nichols.)

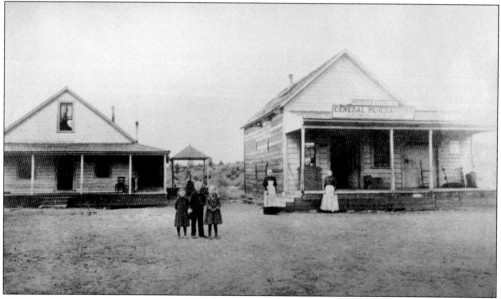

William Wagner and his partner Doc Fairchild built the original Lotus Store in 1893. Around 1900, John Wagner and Francis Veerkamp took over, and they later it was sold to Chris Uhlenkamp. The children are, from left to right, Alice Wagner, Charles Wagner, and Elsie Uhlenkamp. In the background are Mrs. William Wagner and Mrs. John Wagner. (Courtesy of Wayne Ragan and family.)

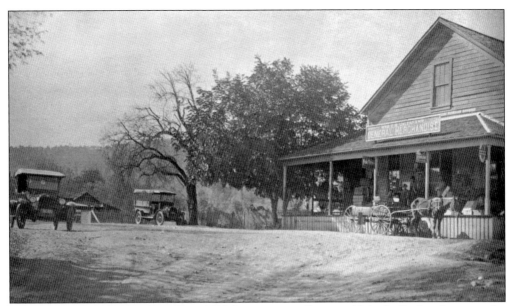

The sleepy town of Lotus dates from 1849. It was originally named Marshall after the man who discovered gold and then was renamed Uniontown to commemorate California's admission to the Union. When a post office was established there in 1881, local storekeeper Adam Lohry changed the name to Lotus. Here, locals gather at the Lotus Store, then owned by the Uhlenkamps, a prominent El Dorado County family. Today, many rafting and kayaking companies headquarter their businesses in Lotus. (Courtesy of MGDSHP.)

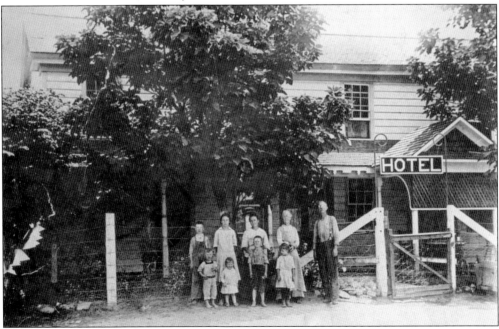

By 1916, the Temperance Hotel had been much improved. From left to right are (first row) Ray Lawyer, Ethel Lawyer, Clarence Turnbeaugh, and Marjorie Hall; (second row) Jim Turnbeaugh, Martha Turnbeaugh, Charlotte Turnbeaugh, Martha Gray, and James Turnbeaugh. (Courtesy of Wayne Ragan and family.)

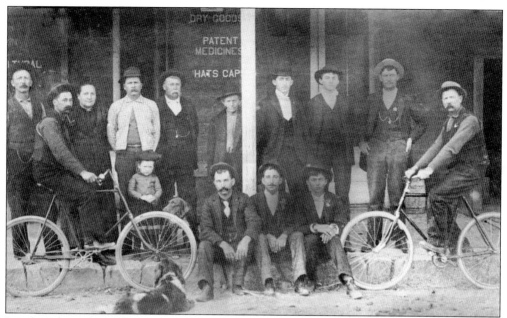

Local residents show off the first Lotus bicycles by the brick Uhlenkamp Dry Goods Store. Over the years, it has also served as a post office, an antique store, and a restaurant. Shown from left to right are (first row) Frank Orelli, Will Orelli, and Charles Immer; (second row) Jim Turnbeaugh, Albert Morris (on bicycle), Alice Turnbeaugh, Elizabeth Uhlenkamp, Wallace Rust, Spencer Norris, Bill Grubbe (by post), Jim Keane, Bill Immer, Bill Othic, and Chris Uhlenkamp (on bicycle). (Courtesy of Wayne Ragan and family.)

In the 1920s, travelers in a horse-driven buggy cross the Lotus Bridge. The town of Lotus is visible to the right. Today, Henningsen Lotus Park, beyond the bridge, provides the community with several athletic fields and a playground. (Courtesy of Clarence and Betty Nichols.)

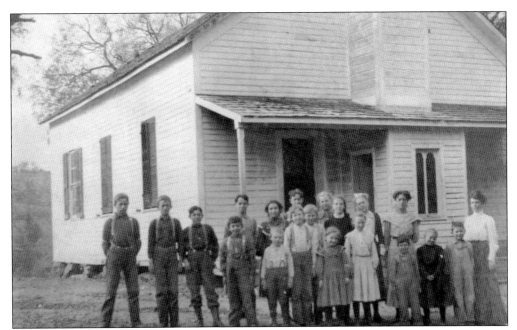

The Uniontown School, built in 1869, educated generations of Lotus children. Shown in this 1898 image are, from left to right, (first row) David Grother, George Grother, Ernest Coonrod, an unidentified boy, George Wagner, Herbert Wagner, Walter Wagner, Helen Gallagher, Alice Turnbeaugh, Dick Gallagher, Lorena Wagner, Allan Gallagher, and teacher Alice Parker; (second row) Leland Borland, Amelia Leonardi, Milo Smith, Elsie Uhlenkamp, Helen Smith, Irma Turnbeaugh, and Annie Grother. The district, formed in 1858, was absorbed into the Gold Trail Union School District in 1964. (Courtesy of MGDSHP.)

Martin Grother, a stalwart citizen of the Lotus community, poses from his horse-drawn wagon by the Lotus Store. Generations of Grothers have lived in Lotus. The family's presence dates back to the Gold Rush. More recently, the Grothers ranched on land behind the current Lotus firehouse. (Courtesy of Clarence and Betty Nichols.)

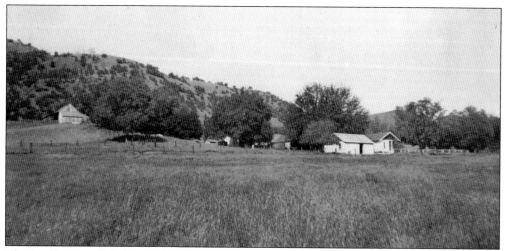

The small town of Michigan Flat thrived just north of Lotus and Coloma, on the site of today's Bacchi Ranch. Thomas Stanford (brother of Stanford University founder and Big Four railroad member Leland Stanford) had a general store here. Charles Smith operated the first store in Michigan Flat, housed in a primitive tent, where miners from nearby Red Hill, Coyote Diggins, and Rich Gulch obtained their supplies. North of the town, at the junction of Greenwood Creek and the river, the elegant two-story Magnolia Hotel served travelers. (Courtesy of Bill Bacchi.)

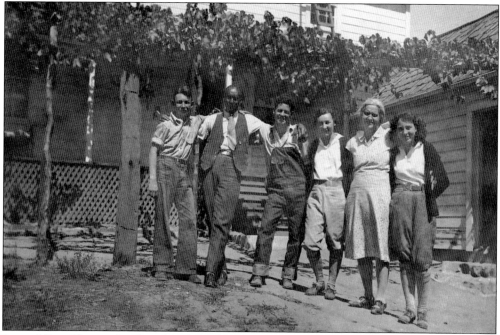

Joe and Rose Hanson lived in this classic farmhouse that he built at the foot of Lotus Grade. In this c. 1930 photograph are (left to right) Ed Pugh, Grant Monroe, the Hanson nephew Albert Mynsted, Pearl Pugh de Haas, Rose Hanson, and Edith de Haas. These families were close friends with the Monroe family of Coloma. Grant cooked for Pearl and her husband, Manfred de Haas, on their honeymoon in Onion Valley east of Georgetown. Many years later, Albert and his wife, Trudy, donated a beautiful tombstone for the Monroe family burial plot in Coloma Pioneer Cemetery. (Courtesy of Pearl de Haas.)

Matsunosuke Sakurai worked for the Veerkamp family in Gold Hill, just south of Coloma. He was part of a group of about 30 Japanese samurai colonists who came to California, led by German-Prussian John Henry Schnell. In Gold Hill in 1869, the colonists founded the Wakamatsu Tea & Silk Farm Colony, the first Japanese settlement in North America. Schnell and the group brought and planted tens of thousands of mulberry, bamboo, and tea plants. (Courtesy of American River Conservancy.)

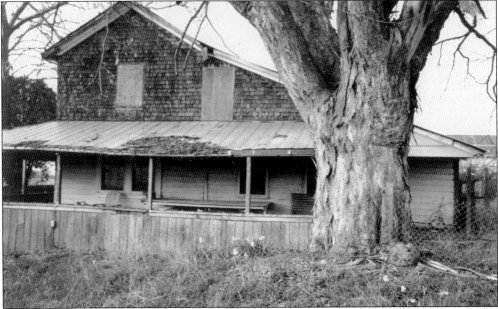

The colony settled on 160 acres of land purchased from Charles Graner in Gold Hill, a couple of miles from Coloma. Plagued by drought and money problems, the colony failed in 1871. Debt-ridden, John Henry Schnell left California, and the fate of all but three colonists is unknown. The young Okei, who had became a nursemaid for the Veerkamp family, died—some say from homesickness, some from illness—at the age of 19 in 1871 and is buried at the Gold Hill site. She is believed to be the first Japanese woman buried on American soil. The Graner/Veerkamp home is shown here before it was restored. (Courtesy of American River Conservancy.)

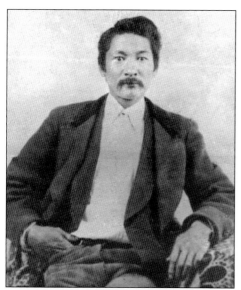

Kuninosuke Masumizu settled in the area and in 1877 married Carrie Wilson, an African American woman from Coloma. He moved to Sacramento, where he became a father, a fisherman, and interpreter. His present family members living in California are the only known descendants of the colony. The colony's story became a best-selling novel in Japan. In the United States, a children's novel recounts the Wakamatsu tale. It is said that Carrie was six feet tall and smoked a corncob pipe. Masumizu was a foot shorter than his bride. In 1941, after the bombing of Pearl Harbor, the FBI visited his widow because she was once married to a Japanese man. (Courtesy of American River Conservancy.)

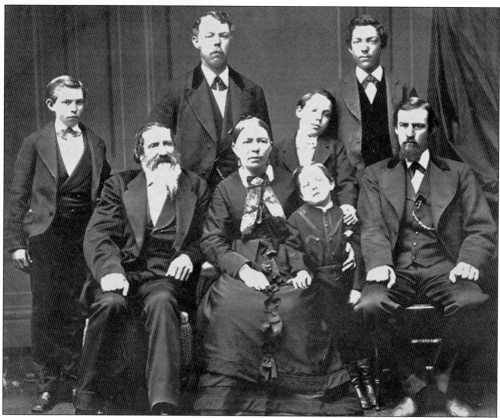

Francis and Louisa Veerkamp and their brood of 10 children (6 shown here in about 1895) took care of the remaining colonists. Francis was born in Germany, came to California in 1852, and soon engaged in ranching. Shown from left to right are (first row) Francis, Louisa, Louis P., and Henry; (second row) Egbert, Frank, Berthold, and William. Veerkamp descendants thrive today throughout western El Dorado County. (Courtesy of Mervin de Haas and family.)

A simple headstone marks Okei's grave on a hilltop overlooking the Coloma Valley. The American River Conservancy, in partnership with the Wakamatsu Colony Foundation, the California Rice Commission, the Japanese American Citizens League, and the National Japanese American Historical Society, purchased the ranch from the Veerkamp family and plans to reconstruct the buildings. Restoration plans include a museum and interpretive center. (Courtesy of American River Conservancy.)

In 1969, Gov. Ronald Reagan posed with children and dignitaries at the dedication of a monument at Gold Trail Elementary School in Gold Hill to recognize the centennial anniversary of the founding of the colony. It is listed as California Registered Historical Landmark No. 815, and in 2010, Wakamatsu was placed in the National Register of Historic Places. (Courtesy of American River Conservancy.)

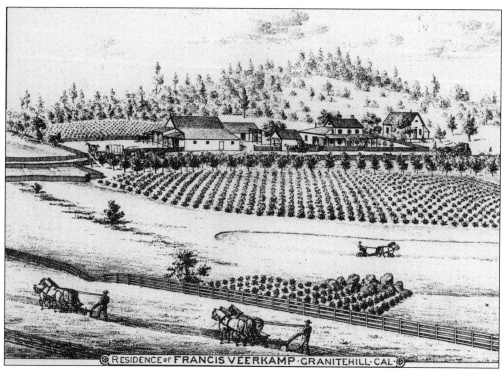

RESIDENCE OF FRANCIS VEERKAMP · GRANITEHILL · CAL

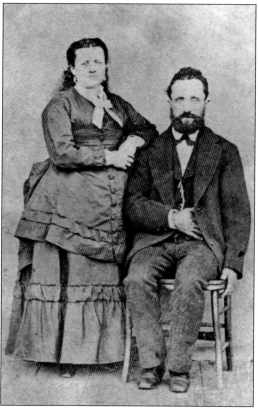

The Veerkamp Ranch thrived in the Gold Hill area. Fertile and relatively warm, Gold Hill specialized in vineyards and orchards. Francis Veerkamp had about 20,000 vines and fruit trees. The village included banking facilities, daily stage services, a telegraph office, bakeries, meat markets, and hotels. Today, the area is known for its citrus, peaches, pears, vineyards, and olive oil. Other longtime Gold Hill families include the Akins, Gastaldis, Marchinis, and Winjes. (Courtesy of American River Conservancy.)

Northwest of Coloma and Lotus, the magnificent Bacchi Ranch sprawls across thousands of acres of grassy hills. Some 1,400 acres of the original Bacchi holdings next to the river are now public land administered by the Bureau of Land Management as a beloved preserve known as Cronan Ranch. Patriarch Guglielmo (William) Bacchi came to the area from Rodi, Switzerland, in the 1850s. Soon after arriving in California, Guglielmo acquired not only wealth from cattle ranching but also his bride, Virginia Pini. (Courtesy of Bill Bacchi.)

Byron Bacchi (center) secures his daughter Carla on a steer while Carla's uncle, Francis Bacchi, helps to steady the animal. Byron and Francis were William's grandsons. In the 1940s, the family used Caterpillar equipment to clear land, build networks of roads, and sculpt farm ponds for their livestock. (Courtesy of Bill Bacchi.)

Photographed along Bacchi Ranch, riders on horseback form a parade en route to a nearby rodeo in the 1950s. (Courtesy of Bill Bacchi.)

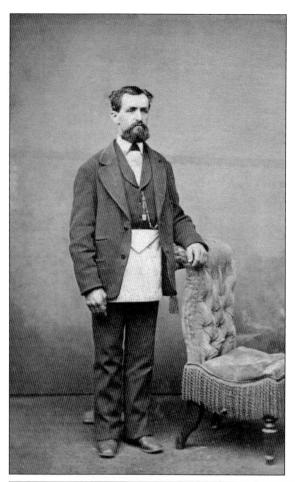

Giosue Bassi stepped off the boat in San Francisco from Switzerland in 1859. He worked at mines and dairy ranches in El Dorado County and later wandered around Nevada before settling in Lotus in 1870, establishing a fine home and dairy at Rockridge near the end of Bassi Road. He married Virginia Forni in 1878, and many of their descendants still live in the county. (Courtesy of Dan Mainwaring.)

About 1925 or 1926, students from Uniontown School in Lotus dress up for a school play. From left to right are Esther Colwell, Lillian Bassi, Herbert Herzig, Hilda Herzig, Clarence Turnbeaugh, Marcella Bassi, and Ernest Herzig. (Courtesy of Dan Mainwaring.)

Nine

RIVER UPS AND DOWNS

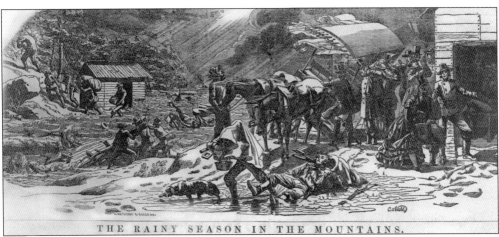

THE RAINY SEASON IN THE MOUNTAINS.

Over the years, the South Fork of the American River, which courses through the heart of both Coloma and Lotus, has both given and taken away. This sketch depicts the terror of a flood in Gold Rush times. Torrential water carried away camps and whole towns. Floods in this part of California occur quickly, inundating low-lying areas in a matter of minutes or hours. In the more benign summer season, swimmers, rafters, and kayakers enjoy the clear water of the fast-moving river. (Courtesy of the California State Library, Sacramento, California.)

In the summer of 1850, John Little, who owned a fine establishment on the north side of the river, built the town's first bridge at a cost of $20,000. Within 90 days, he recouped building costs from toll income. In 1852, a flood wiped out Little's bridge, which he quickly rebuilt. In 1855, a flood wiped out the second bridge. This time a two-truss, 600-foot-long replacement bridge, called the Raun-Pearis Bridge, followed and later was covered in wood. An 1862 flood destroyed it. It was replaced but destroyed again in 1880. The footbridge shown here spanned the river for years afterward. (Courtesy of Jeff and Barbara Lee.)

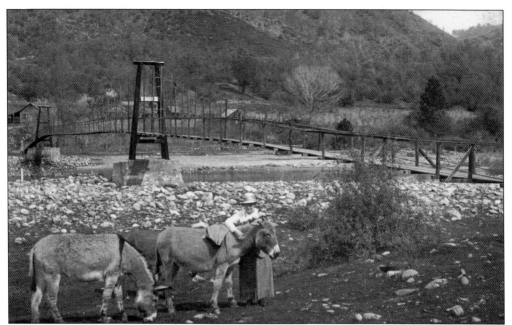

Nancy Vernon poses with two donkeys in front of the footbridge built in 1881 by Roger Cox, a rancher on the north side of the river. The bridge served the community for many years despite being periodically washed out. In October 1886, Cox wanted to sell it to the County of El Dorado but was told it was four feet too low. After adjusting the bridge, he sold it to the county for the sum of $100. (Courtesy of Rita Archie, Philip Fancher, and Vickie Longo.)

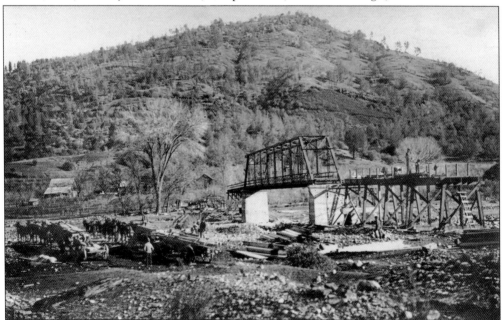

Finally, in 1915, El Dorado County began planning a sturdy, more permanent bridge, which was completed in 1917. Here, wagons bring lumber for the wooden approaches. The one-lane steel arch bridge is still in use today. At first, the bridge featured wood railings at each end. (Courtesy of Rita Archie, Philip Fancher, and Vickie Longo.)

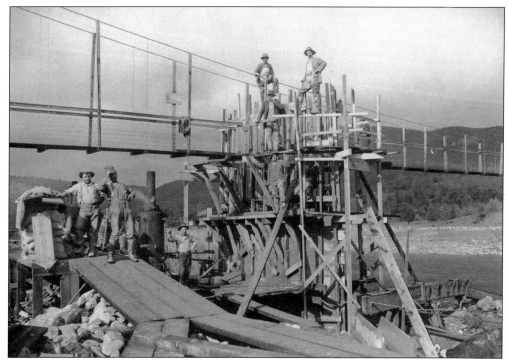

Workers pour concrete for one of the piers of the bridge. The wing walls and abutments were built in two stages, in 1931 and 1936. The bridge is still used, but there are weight and load limits. A replacement bridge will eventually be needed. When this happens, the El Dorado County Department of Transportation may donate the old bridge to the state park for use as a pedestrian bridge and build a wider bridge below Troublemaker Rapid. (Courtesy of MGDSHP.)

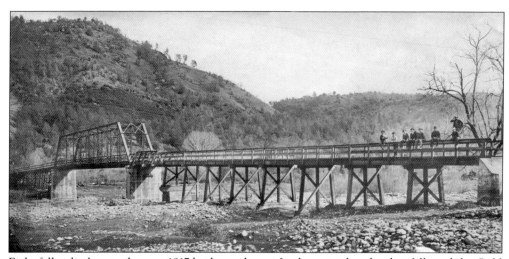

Eight folks climb onto the new 1917 bridge and pose. In the quiet decades that followed the Gold Rush, Coloma gained economically from the fact that it had a bridge, as transport was forced to route through here. Today, visitors strolling on the bridge can see paw prints in the concrete from a long-ago dog. (Courtesy of MGDSHP.)

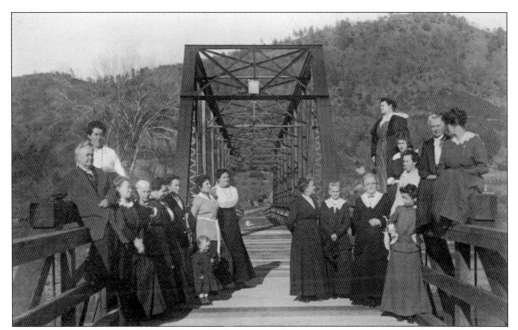

Coloma ladies gather at the Coloma Bridge soon after construction was complete. From left to right are Josephine Norris, Mrs. Hall (seated on rail), Annie Thole, Julia Johnson, Cora Thomas, Louise Gallagher, Gallagher child, Hattie Colwell, Angie DeLory, Ollie Thomas, Jane Stearns, Lizzie Crawford, and Mamie Thomas; (on rail) Sadie Anderholder, Cecilia Papini, Dorcas Papini, Mrs. Stolfus, and Annie Thomas. (Courtesy of MGDSHP.)

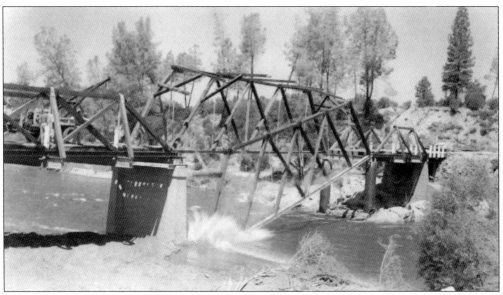

Workers blast the old Lotus Bridge into the water. The bridge had been damaged by floodwaters in 1950. It was replaced by the new upstream Highway 49 bridge in 1951. The foundation of the old bridge is still standing today at Henningsen-Lotus Park in Lotus. (Courtesy of Bill Bacchi.)

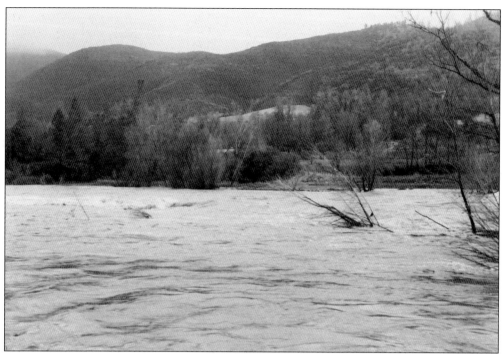

Flooding has long plagued the valley. An 1850 flood wiped out mining camps in Coloma and submerged the fledgling city of Sacramento. Floods also occurred in 1852, 1855, 1862, 1881, and in later years. This 1964 view shows the Sutter Mill Monument completely covered by water. Floods typically occur when warm, heavy rain falls at high elevations on a Sierra snowpack, causing the snow to melt quickly. The so-called "Pineapple Express" weather pattern can be deadly. (Courtesy of MGDSHP.)

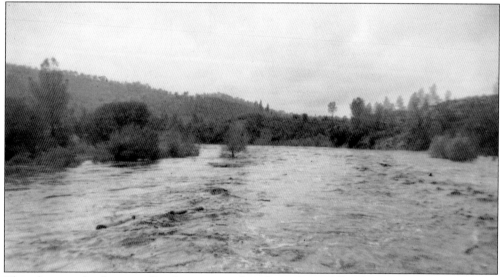

This photograph of surging floodwater was taken from the middle of Lotus Bridge. The South Fork of the American River flows from the high peaks of the Desolation Wilderness Area west of Lake Tahoe. A major arm of the river, Silver Fork, feeds from the south at Caples Lake near Carson Pass. (Courtesy of Bill Bacchi.)

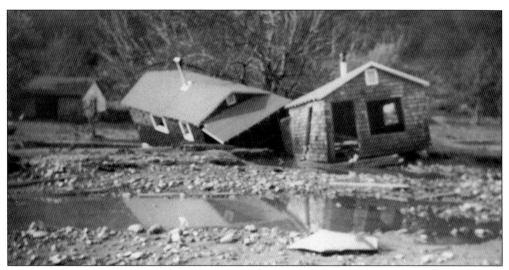

Pictured after a 1950 flood, ruins of Coloma houses lay topsy-turvy along the riverbank. The largest flood on record occurred in 1955; another massive flood wreaked havoc in 1997. In recent years, smaller floods have also occurred in 1964, 1980, 1986, and 2005. (Courtesy of Pearl de Haas.)

The cascades of the river have tempted agencies searching for hydroelectric power and water. In 1977, the El Dorado Irrigation District proposed the SOFAR (South Fork of the American River) project. The project, now shelved (in part because high riverfront property values would make the undertaking cost-prohibitive), would have created two dams on the lower river: one large dam just below Weber Creek that would have created a reservoir up to Highway 49 and the other a small afterbay close to the Salmon Falls Bridge, actually in Folsom Reservoir. On the upper river, two reservoirs would have reached from just above Troublemaker Rapid to Highway 193. Only Coloma itself would have been spared because of a constitutional prohibition enacted decades earlier. (Courtesy of Sara Schwartz Kendall.)

Before Chili Bar Dam was constructed in 1964, the river flowed warm and low in the summer, permitting swimming, as shown by these bathing beauties from the 1920s. Bass and frogs proliferated. Before Folsom Reservoir and Lake Natoma were constructed in 1955, salmon made it all the way to Kyburz to spawn. After the Chili Bar Dam was built, river water became much colder. (Courtesy of Rita Archie, Philip Fancher, Vickie Longo.)

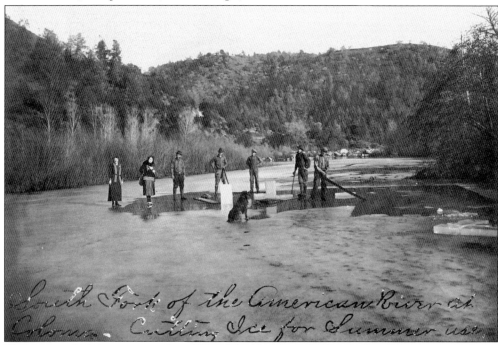

The winter of 1911 was unusually cold, enabling local residents to cut ice from the river at this slow-moving stretch of water below Troublemaker Rapid. The blocks of ice were welcome for preserving food. (Courtesy of MGDSHP.)

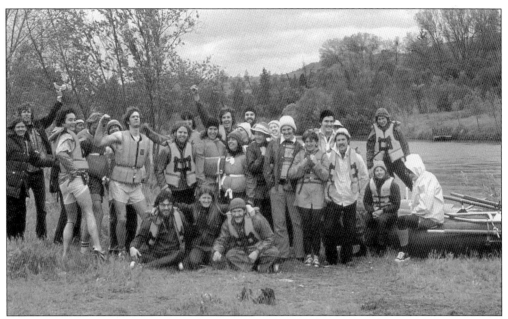

Gold of another sort came to the Coloma Lotus Valley in the 1960s, when kayakers and rafters discovered the ideal whitewater on the South Fork of the American River. Around 1963, Lou Eliot of Oakland started a company called Adventure River Trips, which evolved into American River Touring Association (ARTA) in 1969 or 1970. Here an ARTA training class from 1978 sports bulky Mae West life jackets. (Courtesy of Bill Center.)

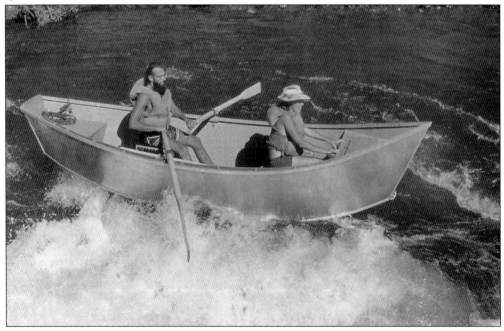

In those early days, one might find an aluminum dory, such as this one rowed by Sparky Kramer, with Terry Goss as the passenger. The dory originally was built for ocean-going duty, with the rower facing the back. The rocks in the river would have damaged the brittle vessel. (Courtesy of Bill Center.)

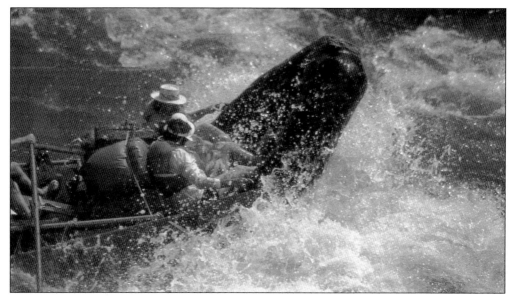

Big black Yampas, made by Rubber Fabricator in West Virginia, were among the first rafts to be used on the river. Contemporary rafts are made in England (Avon) or in Asia. Early-day rafters and guides often settled in the valley, many becoming a part of the conservation movement. Since the early 1990s, the American River Conservancy, based in Coloma, has led the way in land acquisition for wild open space along the river. (Courtesy of Bill Center.)

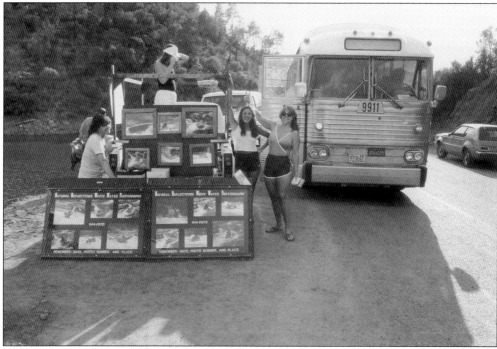

Photographers exhibit whitewater artwork at the congested Salmon Falls Take Out at Folsom Reservoir. Natural Reflections, later Rapid Shooters, and still later Hot Shots and Vita Boating have marketed photographs of rafters careening through rapids such as Troublemaker, Hospital Bar, and Satan's Cesspool. (Courtesy of Bill Center.)

Kayaks line up at Nugget Campground, just upstream from Chili Bar Resort. Kayaks then were all four meters long, the maximum length allowed in European boxcars. For racing, longer boats went faster. Kayaks later became much shorter and more maneuverable, making them better suited to the rocks and fickle river currents of the American River. (Courtesy of Bill Center.)

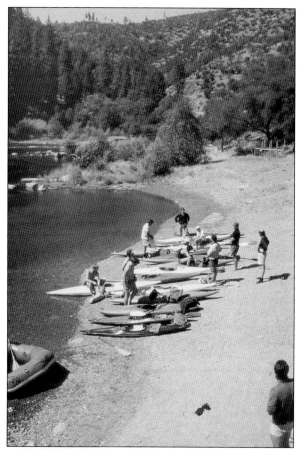

Don Favor, owner of Chili Bar Resort, bought the business from Joe Stancil around 1972. Shown here in 1976, Favor enjoys his time on a raft that was one of the first non-military rafts made in the United States. Favor was an Olympic hammer thrower in the 1936 Olympics and later a schoolteacher in Maine. (Courtesy Bill Center.)

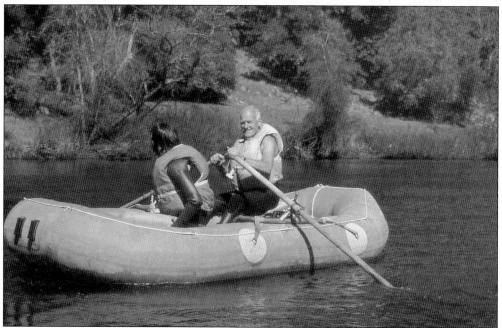

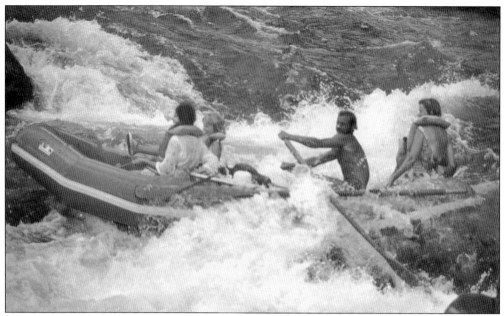

Rules were less stringent in the early days of the rafting industry. In this 1972 image, Jimmy Katz, an ARTA river guide, does not wear a life jacket as he plummets through Satan's Cesspool. The passengers are wearing horse-collar life jackets. Today, about 20 major and 20 smaller companies operate along the river, with $12 million directly invested in the local industry. (Courtesy of Bill Center.)

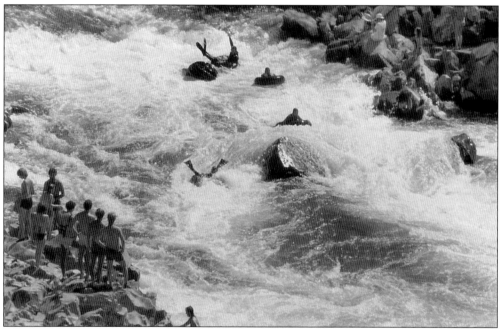

Equipped only with inner tubes and swim fins, adventure seekers in the 1970s bounce down Troublemaker Rapid. Life jackets are conspicuously absent. Today, the El Dorado County Sheriff's Department strictly enforces safety rules; likewise, commercial companies adhere to high safety standards, making fatalities rare. (Courtesy of Bill Center.)

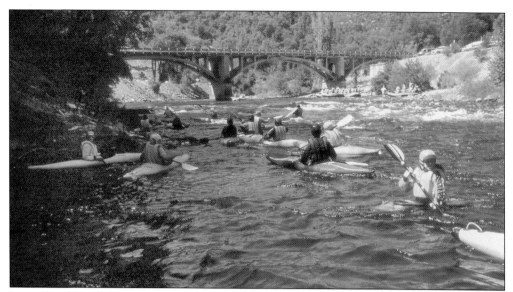

In outdated long kayaks, adventurers prepare to launch downstream to Coloma at the Chili Bar Bridge. Most of the rafting and kayaking on the South Fork of the American River takes place in two major sections featuring Class III and III+ waters: the Upper and the Lower. The Upper is faster, shorter, and more technically demanding. The Lower mixes long stretches of slow-moving water with lively rapids. Commercial rafting companies often serve up riverside picnics on this section of the river, which runs past Cronan Ranch and ends at Salmon Falls, the upper end of Folsom Reservoir. (Courtesy of Bill Center.)

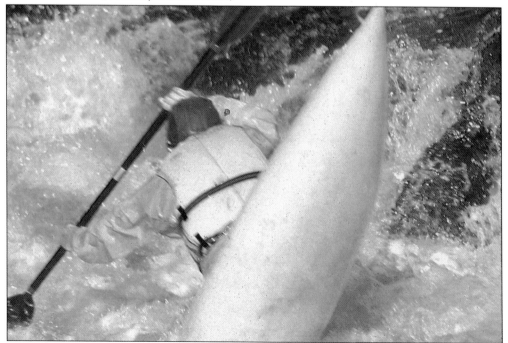

In 1976, a kayaker does a nose stand at Satan's Cesspool in his Hollowform "banana boat," one of the first plastic boats. Before these malleable plastic kayaks, the boats were made of fiberglass, a material that often cracked if the kayaker hit a rock. (Courtesy of Bill Center.)

DISCOVER THOUSANDS OF LOCAL HISTORY BOOKS FEATURING MILLIONS OF VINTAGE IMAGES

Arcadia Publishing, the leading local history publisher in the United States, is committed to making history accessible and meaningful through publishing books that celebrate and preserve the heritage of America's people and places.

Find more books like this at
www.arcadiapublishing.com

Search for your hometown history, your old stomping grounds, and even your favorite sports team.

Consistent with our mission to preserve history on a local level, this book was printed in South Carolina on American-made paper and manufactured entirely in the United States. Products carrying the accredited Forest Stewardship Council (FSC) label are printed on 100 percent FSC-certified paper.

MADE IN THE USA